MASTER PIECES UP CLOSE

By Claire d'Harcourt

chronicle books · san francisco

To Victor,

Espérance,

and Valentine

The fame of many art masterpieces has worn them out: We have seen them so many times that we don't really stop to look at them anymore. *Masterpieces Up Close*, however, gives you the chance to take a fresh look at some familiar images. Examine the details of Rembrandt's *Night Watch* and Michelangelo's frescoes on the ceiling of the Sistine Chapel. Uncover the hidden message in Velásquez's *Las Meninas* and Dalí's *Persistence of Memory*. Decode the language of symbols in Jan van Eyck's *Arnolfini Wedding Portrait* and Hieronymus Bosch's *Haywain*. Seek the details in each painting. In the captions, you'll find many questions, and in the explanations that follow each century's masterpieces, you'll discover some answers. Some of these paintings are so puzzling, though, that art historians still can't fully explain them. Sometimes, it is a masterpiece's very mystery that has fascinated us for centuries.

1

Italian painter and art historian Giorgio Vasari notes in his *Life of Giotto,* "It is said that when Giotto was only a boy with Cimabue, he once painted a fly on the nose of a face that Cimabue had drawn, so naturally that the master, returning to his work, tried more than once to drive it away with his hand, thinking it was real."

2

In this scene, many elements emphasize the theme of flight: the procession of feet and hooves, the angel's gesture toward Egypt, the triangular rock that echoes the shape of the mother and child on the donkey. Everything seems to move forward along with the travelers.

3

At right, a man starts to take off his robe; on his left, a man pulls his robe over his head; and, next to him, a man bends down toward the hooves of Christ's donkey. Giotto showed movement by representing successive stages of an action, as in single frames of an animated movie.

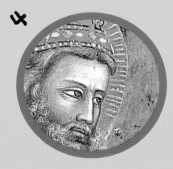

4

Giotto was one of the first painters to individualize faces. Every expression and every character is strikingly lifelike. What expression does this face have?

GIOTTO di Bondone

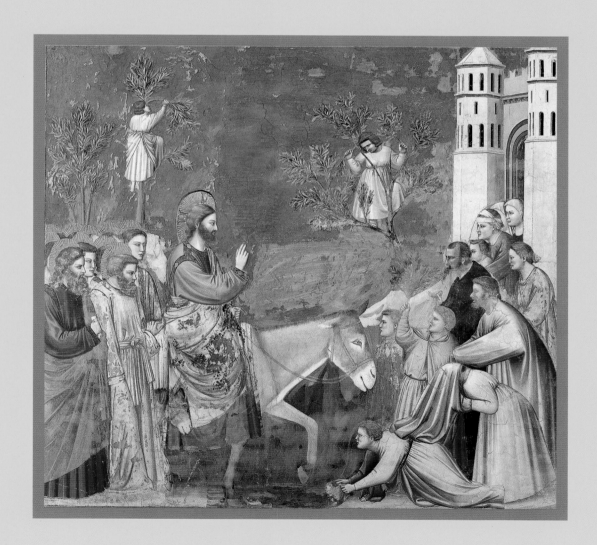

Zoos did not exist in Giotto's time, and, living in Italy, he had never seen a camel. He imagined it to have a donkey's ears and blue eyes!

6

We are told that the Magi were astrologers who had read in the sky the arrival of Christ. Giotto pictured the star that guided the Magis' way to Jesus like Halley's comet, which appeared in 1301 and which he probably saw.

7

The angel holds one of the luxurious gifts brought by the Magi. This object is treated naturalistically, like the comet. Giotto wanted to represent things as they appear in nature, not stylized, as artists before him had done.

8

Giotto painted with precision and with consistent attention to detail. Do you think these blue splotches are a mistake?

Arena Chapel circa 1305

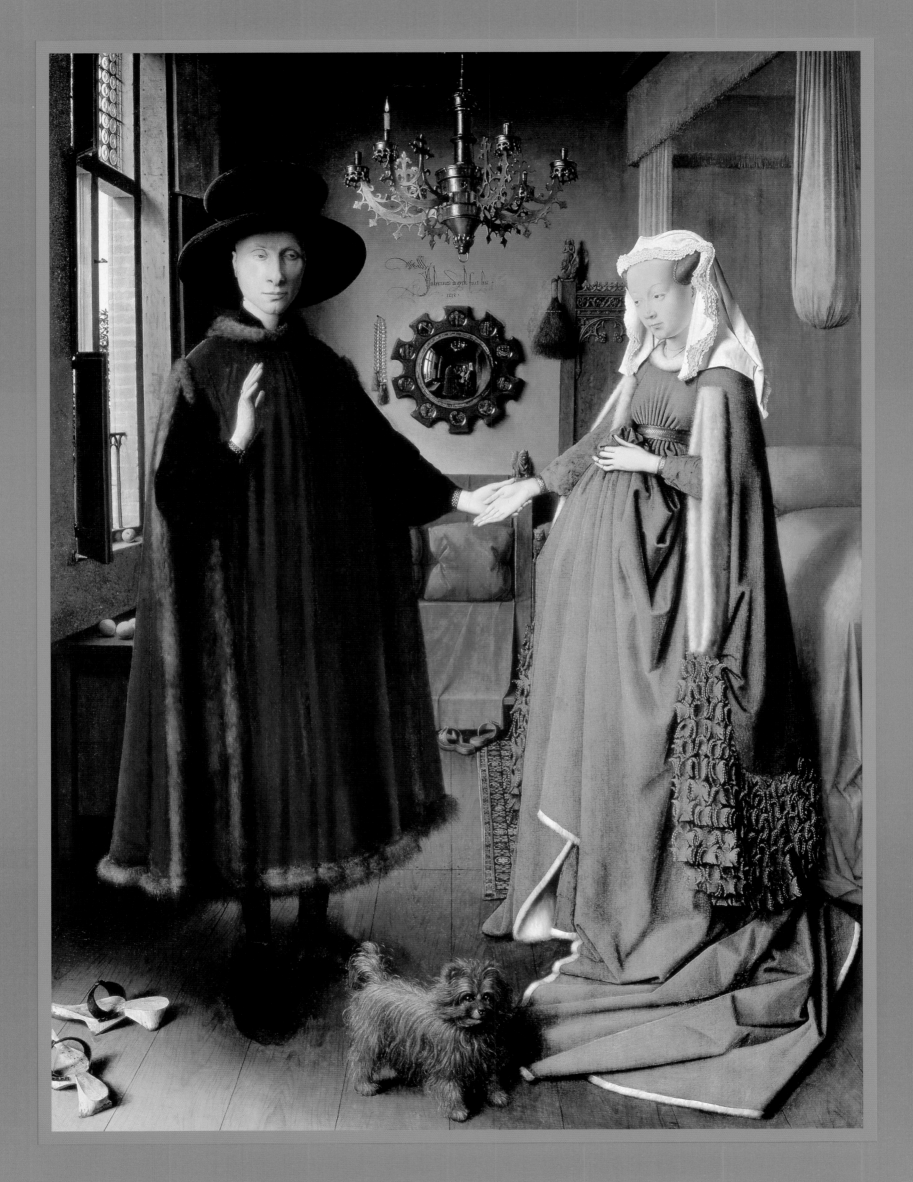

Jan VAN EYCK

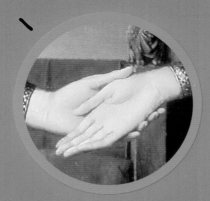

1

A man holds his fiancée's hand and raises his right hand as an oath-taking gesture, or perhaps he is getting ready to put it on his wife's hand to seal their union. Until the sixteenth century, couples could be married outside a church and without a priest.

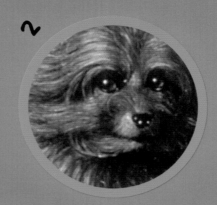

2

A little dog, a symbol of fidelity, witnesses the wedding. Sculpted lions symbolize the strength and courage of the spouses. Although we may find van Eyck's painting difficult to decipher today, the objects in it spoke a language familiar to his audience.

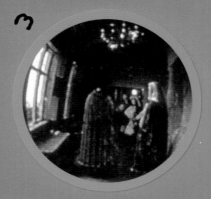

3

Isn't that the painter himself, dressed in blue, who we can make out in the reflection of the mirror? He stands next to a young man in red, and they watch the scene from the doorway. The mirror also reflects the two spouses from behind.

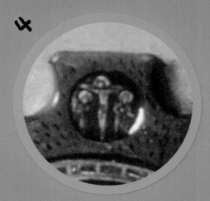

4

The mirror frame is encrusted with ten medallions painted in minute detail. They depict scenes from the life of Christ, who is the spouses' spiritual protector.

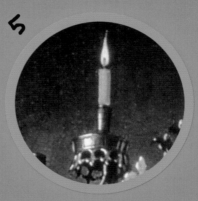

5

There is only a single lit candle in the chandelier. Like a church candle, it symbolizes the light of the soul and represents the eye of God. For van Eyck and other Flemish painters of his time, God was present in all objects.

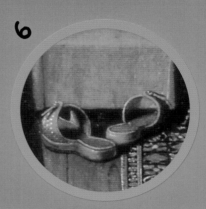

6

The spouses have both taken off their shoes so that their feet are in contact with the floor, which becomes symbolically holy ground. It's also because of superstition: People believed at the time that touching the floor with bare feet helped them have children.

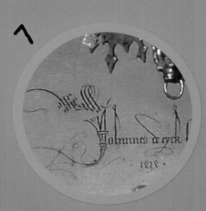

7

An ornate inscription reads, "Johannes de eyck fuit hicc." What do you think it means, and why did van Eyck paint it in such an unusual place?

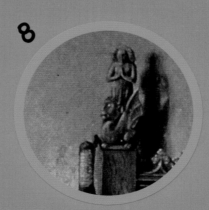

8

A statuette of Saint Margaret, the patron saint of childbirth, atop the back of a chair, represents the couple's wish to have many children.

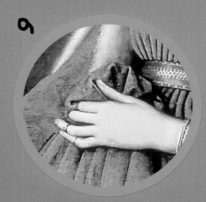

9

The bride is lavishly dressed in a green, fur-lined wool robe with carefully draped pleats. She pulls her robe up and holds her hand on her belly. Could this young woman be pregnant?

Arnolfini Wedding Portrait 1434

1

The grass, dotted with forget-me-nots, cornflowers, irises, carnations, and periwinkles, resembles a multicolored carpet. This painting was created to cover a large section of wall where it could replace a much more expensive tapestry.

2

Zephyr, the personification of the west wind, his cheeks puffed out and still blue from the winter cold, squeezes his way through the trees. This herald of spring (*primavera,* in Italian) wears a fervent expression and stares deep into the eyes of the woman he seizes.

3

Standing guard at the entrance to the garden, Mercury, messenger of the gods, wears winged sandals that enable him to fly. With his magical staff, he chases away the clouds, symbols of time and unhappiness.

4

To create this picture, Botticelli first sketched a precise drawing on the huge wood panel. Then he applied tempera paint, made by diluting pigments with egg.

5

Who are these women clad in transparent garments? And who is the woman subtly gesturing toward them? Is she a queen, a goddess, or a madonna?

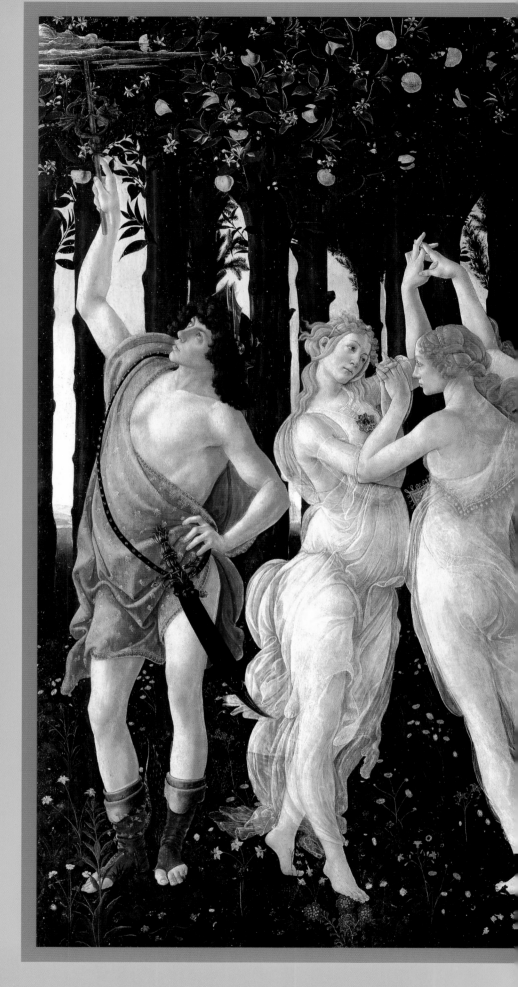

6

Blindfolded, Cupid, the god of love, aims a golden arrow, whose burning tip will cause its victim to fall in love.

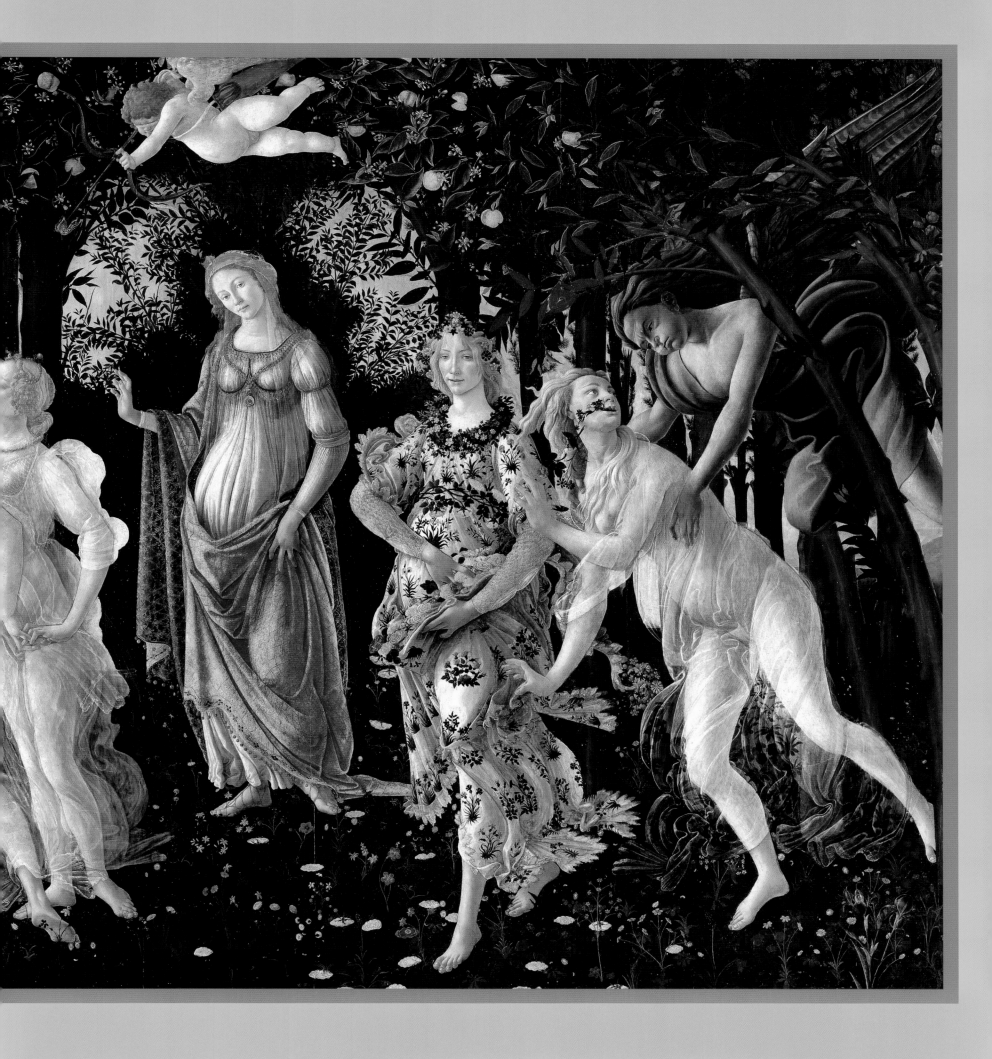

Sandro BOTTICELLI
1478
Primavera

THE PAINTING OF EMOTION

After a long journey, the three Magi arrive before the newborn Jesus. They came from afar, riding camels, guided by a star. Here, the travelers contemplate the divine child. Their faces reflect their adoration (4). This is one of the first times in the history of painting that postures and expressions express emotions. In the following scene, Joseph flees to Egypt with his family to escape King Herod. In another "picture," Christ is baptized. In the last scene, he enters Jerusalem, where he will soon be crucified. To welcome him, two boys gather olive branches, symbols of Christ's future martyrdom. Giotto painted these scenes in fresco, a technique in which paint is applied to wet lime plaster; as the plaster dries, the pigments become "imprisoned" in the wall. Certain colors, however, must be applied after the plaster has dried, but these don't last as long. For example, the blue pigments, obtained from a semiprecious stone called lapis lazuli,

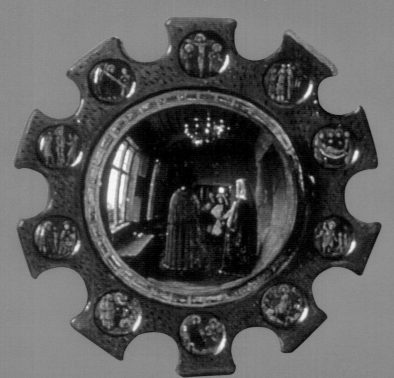

A MARRIAGE CONTRACT

The big day has arrived: Wealthy Italian merchant Giovanni Arnolfini is marrying the daughter of a businessman. Van Eyck's job was to paint an account of this solemn moment as a kind of marriage certificate. To emphasize his role as witness, van Eyck signed the words "Jan van Eyck was here" in Latin in the middle of the painting (7). The presence of this signature is even more unusual because van Eyck was one of the first artists to sign his works. The convex mirror, another innovation, is successfully illusionistic.

THE MIRACLE OF SPRING

It's a beautiful spring morning, and the trees are covered in white flowers and golden fruits. Zephyr, the west wind, catches the nymph Chloris, who tries to escape his grasp. At the same instant, flowers cascade out of her mouth as she turns into Flora, the goddess of springtime. This new goddess is shown at her side in a bright flowered dress. But who are the three women who dance nearby? Many interpretations have been made of this painting, in particular about the nature of these three figures. They are the three Graces, daughters of Zeus and goddesses of beauty who inspire the arts (painting, dance, music). In the center of the painting, Venus, goddess of love, appears. She makes a vague gesture with her right hand—either in benediction or to conduct the dance of the Graces (5). The trees create a circle around her head, like the vault of a temple or the rose window of a cathedral. Although all of the characters in this painting are figures from Greco-Roman mythology, Christianity is also present. For example, the painting measures more than six feet (two meters) tall, a dimension reserved for sacred

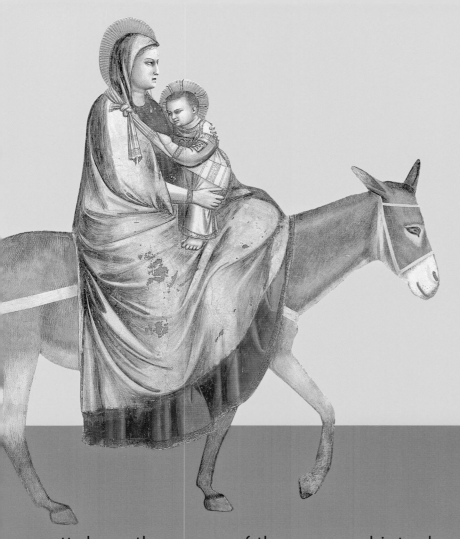

have almost disappeared—this is why only a few patches remain on Mary's robe (8). These frescoes are located in the little Arena Chapel (sometimes called the Scrovegni Chapel), in Padua, Italy. The forty scenes narrating the life of Christ are Giotto's masterpiece. Among the most famous works of art of all time, they have inspired generations of European painters.

It shows the reverse of the scene and introduces another, larger space into the scene. The young bride wears a green dress, the color of hope (of future motherhood). She is not pregnant, despite her prominent stomach: a round belly was fashionable at the time. In fact, women even put padding under their dresses to make their abdomens look rounder (9)! Despite the serious nature of this scene, love is discreetly present: the marriage bed is red, symbolizing passion. Van Eyck revolutionized art by adopting a new realism. He chose to represent more or less ordinary people—merchants and burghers (members of the middle class)—instead of kings or aristocrats, or Biblical figures. The artist was able to depict objects in such lifelike detail because he used oil paint. With all of his innovations, van Eyck profoundly influenced European painting.

paintings. Revolutionary for its time, *Primavera* delivers the message that the contemplation of earthly beauty permits one to attain spiritual beauty. To transmit his message, Botticelli uses a coded language: Only the initiated can truly understand the deep meaning of his art. It was as if he feared that unveiling his paintings' mystery would make them lose their power.

1

Christ appears in a solar disk in the middle of the clouds. Resigned, he sadly contemplates his creation. The only figure who seems to recognize his presence is the angel opposite the blue demon on top of the hay wagon (haywain). Humanity must choose between angel and devil.

2

A swarm of winged scorpions, salamanders, and stinging insects falls from the sky: It is the fall of the rebel angels as described in the book of Revelations. Below, God makes Eve appear from Adam's rib. To the right, she is tempted by the serpent who gives her the fruit forbidden by God. On the back of this panel, Adam and Eve are chased from Paradise.

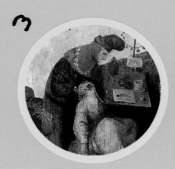

3

The quack, his pockets full of hay from the wagon, tends to a patient. He illustrates deceit born from greed. Below, one man kills another for a few fistfuls of hay. A group fights near the wagon. Bosch shows how greed and avarice provoke theft and violence.

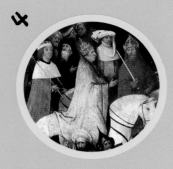

4

The crowd is composed of people from every class of society. The pope, the emperor, and the king ride horseback behind the hay wagon. They are the only ones not clambering for the hay, as if they are its rightful owners.

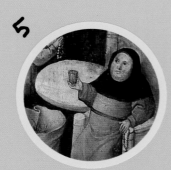

5

A potbellied monk drinks a glass of wine while he waits for the faithful to fill his enormous sack of hay. Bosch was criticizing the Catholic Church's thirst for wealth and its decadence.

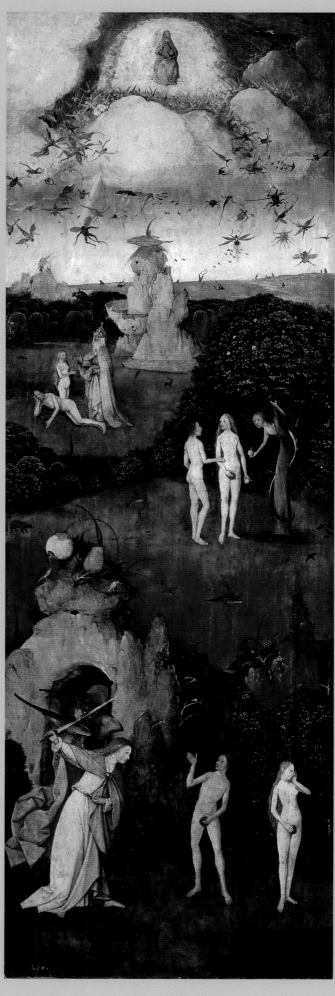

6

Bosch's paintings often include nightmarish creatures, composed of human, animal, and vegetal elements. Here, they pull the hay wagon. What do you think this action symbolizes?

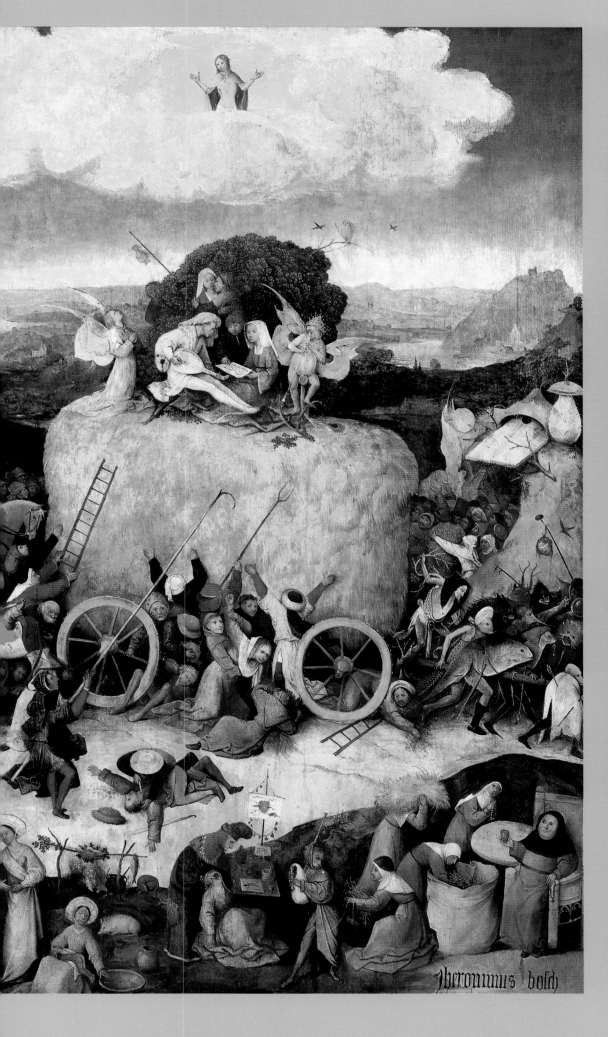

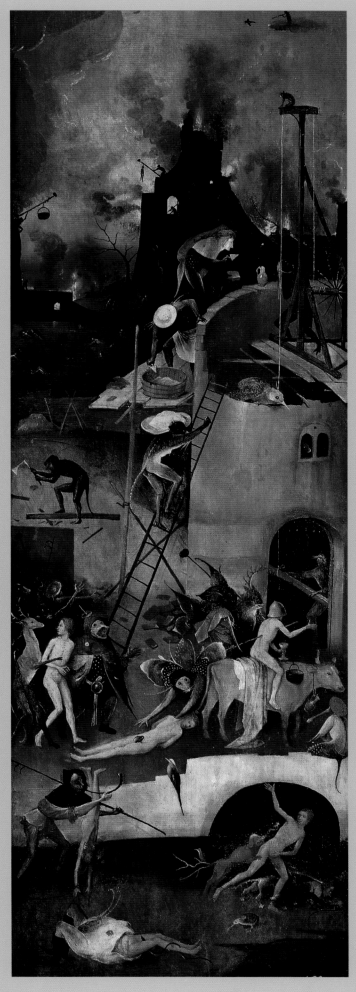

Hieronymus BOSCH
The Haywain
circa **1500**

1

Leonardo creates the impression of depth in this imaginary landscape by using different shades of green and blue and by slowly making the contours more hazy as they approach the horizon.

2

The sitter's hands, folded one over the other, balance her posture and contribute to the harmony of the overall composition. This gracious and wise pose mirrors the sitter's smile and expression. The smooth, clear skin of her hands stands out in the shadows and illuminates the lower portion of the canvas.

3

"The nose, with its ravishing delicate pink nostrils, was life itself," wrote Giorgio Vasari about the *Mona Lisa*. Leonardo diluted his oil paint with turpentine to create a transparent substance called glaze. By painting layer after layer of glaze, he was able to model the face using light and shade. Using glaze allowed Leonardo to paint extremely realistically.

4

Why is she smiling such a mysterious smile? Some believe that in order to distract his model from the sorrow of the recent loss of a child, Leonardo hired performers to keep her entertained. Others think that the smile was painted by the artist in an attempt to portray the divine nature of the soul.

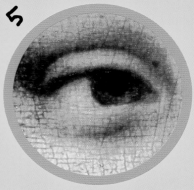

5

Her gaze is intense and her eyes are lifelike. We even seem to see in them a faint glimmer of malice. But who was the woman who posed for Leonardo? Did she really exist?

LEONARDO da Vinci

Mona Lisa

circa 1505

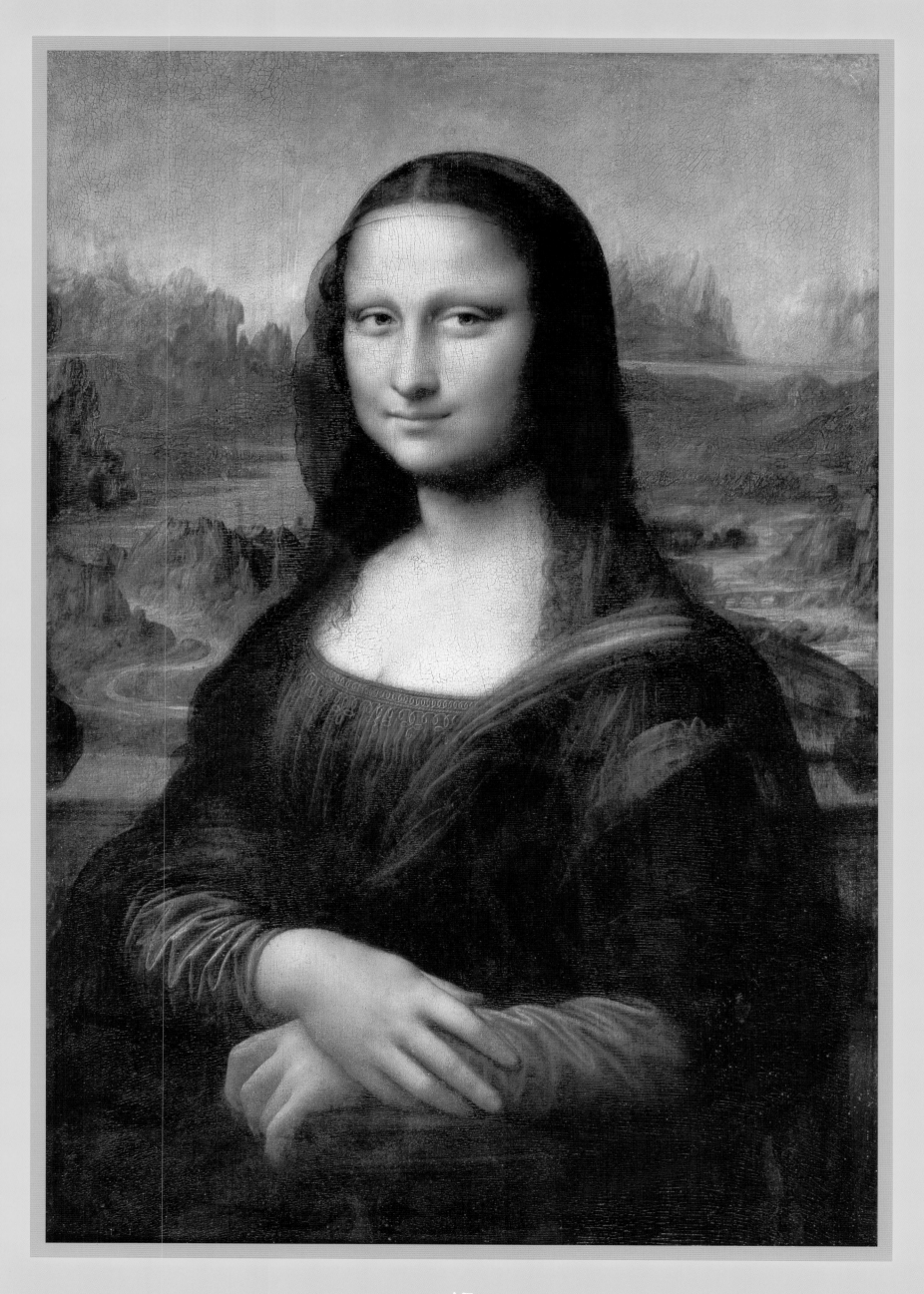

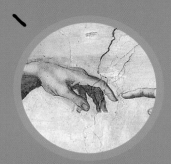

1

In the center of the image is the famous gesture of God giving life to humanity. His finger nearly brushes Adam's, as if he transmits a soul to Adam through a divine spark.

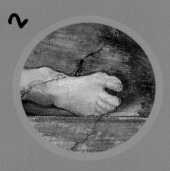

2

According to the book of Genesis, "God created man in his likeness." Michelangelo painted the first man, Adam, to resemble God and made them the same scale. His figures display his mastery of movement and human anatomy.

3

God is surrounded by a crowd of angels and carried through the sky by a mantle that billows out behind him like a sail. Everything emphasizes his life force: the folds of his mantle, his robe, the curls of his hair, and his beard.

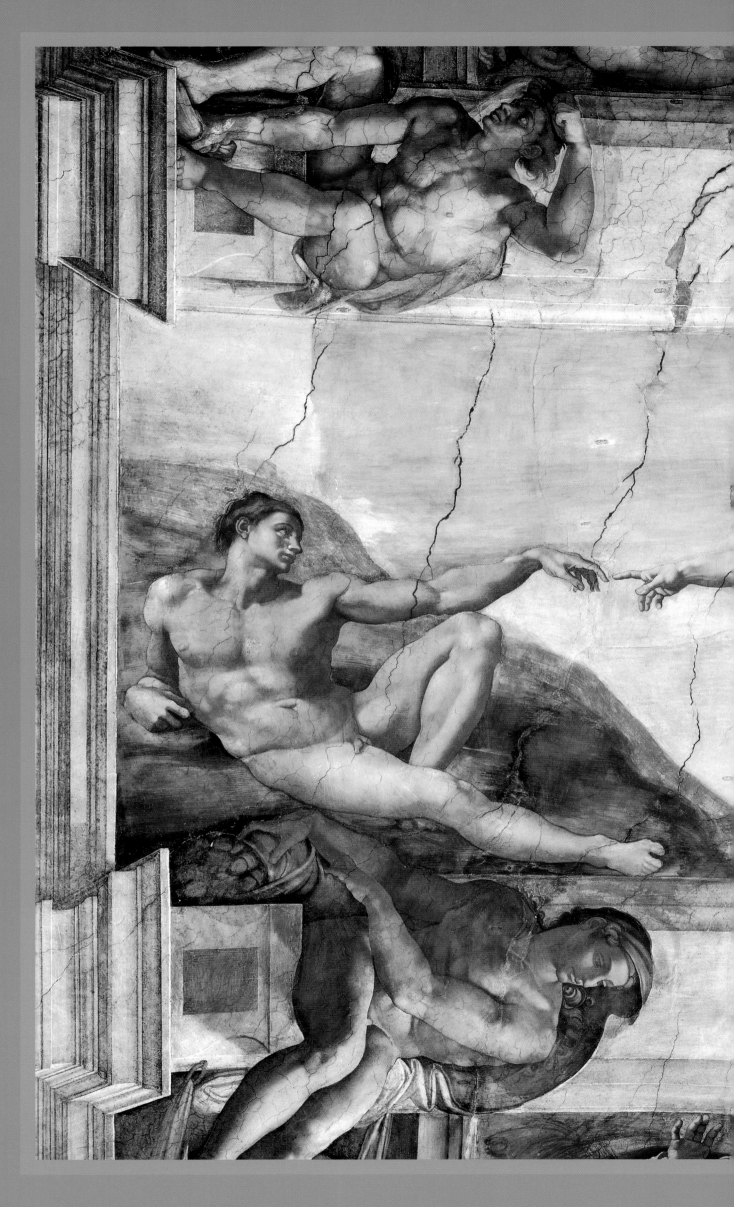

MICHELANGELO Buonarroti

4

Michelangelo painted architecture on the vaulted ceiling of the Sistine Chapel to structure his composition. Imaginary marble windows, cornices, thrones, and pilasters give the painting a framework and provide depth.

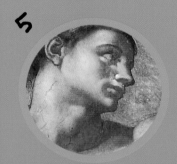

5

Stretched out on Earth, all alone, Adam looks as if he's waking up from a deep sleep. By contrasting Adam's languid, nude body with the energetic, clothed Creator, Michelangelo emphasized the opposition between the human and divine conditions.

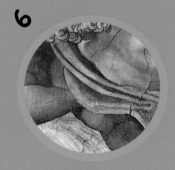

6

Over time, these frescoes became dark and dull. But a recent restoration revealed the brightness of the original painting. How was Michelangelo able to achieve such vivid colors?

Creation of Adam
(detail) Sistine Chapel ceiling circa 1510

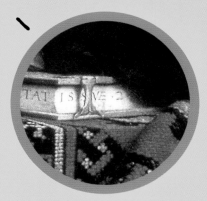

1

The ambassador's age (29) is inscribed on his ceremonial sword, and the bishop's age (25) appears on the edge of the book underneath his elbow. The ambassador wears an imposing fur-trimmed coat and is decorated with the order of Saint-Michel, the highest distinction in France.

2

On the table is a group of scientific and musical instruments, including a navigational tool for sailors to calculate their position by looking at the stars, a device to measure the position of the planets, a sundial, and a lute.

3

Holbein painted a globe of the heavens on top of the table and a globe of Earth on the shelf below to symbolize the interest the two men have in astronomy, geography, and the discovery of new worlds.

4

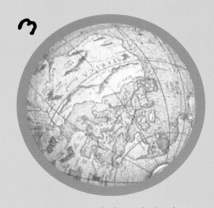

On the lower shelf is a mathematics book and an open hymnbook. During the Renaissance, when people were trying to understand the laws that govern the world, mathematics was one of the most important disciplines. The book of psalms, on the other hand, alludes to the ambassadors' religious tolerance.

5

What is this strange object that seems to float in space, and why did Holbein put it in such a prominent place? If you look at this painting in a certain way, you'll find a hidden message.

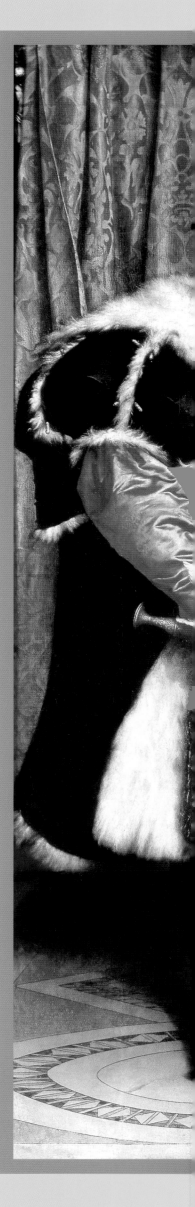

Hans HOLBEIN the Younger

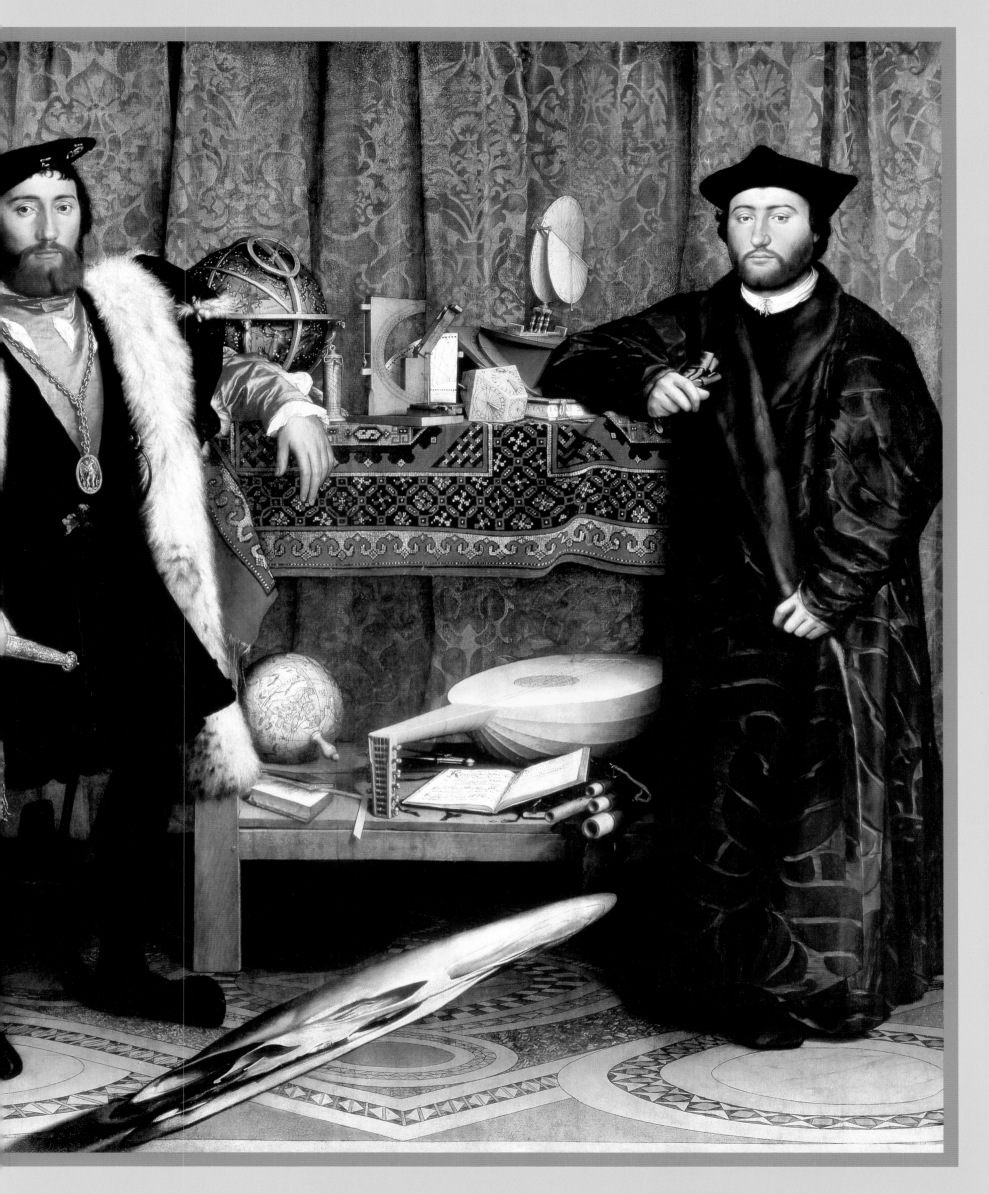

The Ambassadors

1533

THE BLINDING OF MEN

"All the world is a haystack, and each man plucks from it what he can," goes a Flemish proverb. The enormous hay wagon (haywain) in the middle of this triptych (a painting on three panels) is a symbol of the vanity of earthly goods and human greed (6). People pounce on the wagon to grab fistfuls of hay:

A MYSTERIOUS SMILE

"Can you not see that amongst human beauties, it is a beautiful face that stops passersby . . . ?" Leonardo appears to have predicted the worldly success of his masterpiece, popularly called the *Mona Lisa.* To this day, no one has identified the sitter for certain—it's even been suggested that the painting was a self-portrait! Most, however, agree that it is Mona Lisa, the wife of a wealthy Florentine banker, but there is no definite proof (5). Whether or not Leonardo painted a real person, he did try to capture the subject's soul. He exalts and idealizes the human face, searching for perfection. Though mystery hovers over the sitter's identity and her elusive smile, there is mystery, too, about the techniques Leonardo employed to paint her. He used a technique called *sfumato,* in which contours are blended to create "evaporated" colors. Leonardo also employed chiaroscuro: He

THE CREATION OF THE FIRST MAN

With a creative impulse, God the Father holds his hand out toward the first human, Adam, and bestows life on him. Michelangelo, commissioned by Pope Julius II to decorate the ceiling of the Sistine Chapel in Rome, organized his composition around nine scenes from the book of Genesis, including this one of the creation of Adam. It took him four years to complete the job. To prepare for a work of such massive proportions, Michelangelo drew many sketches and studied figures and poses. "I've got myself a goiter from this strain. . . ," he once wrote. "My belly's pushed by force beneath my chin." Michelangelo worked alone, lying on his back on the top of enormous scaffolding, and he had to work quickly to finish before each section of fresh plaster dried. He used pigments diluted in water to create a rich palette of bright, luminous colors (6). Michelangelo's

A HIDDEN IMAGE OF DEATH

Holbein depicts Bishop Georges de Selve visiting his friend Jean de Dinteville in London. Both were French ambassadors (of King Francis I) to King Henry VIII. Between the two men, Holbein painted a still life with all the symbols of human knowledge, an homage to science and the arts, disciplines with which these two human-ists associated themselves. But why did Holbein paint a puzzling shape on the floor between them, disrupting the order and serenity of the image? It is an anamorphic image—one that has been intentionally

Selfishly searching to benefit from the present, they rush at earthly goods whose value is only illusory. In *The Haywain,* one of Bosch's major works, the present (on the central panel) lies between the past (paradise, on the left wing), and the future (hell, on the right wing). Busy stuffing their pockets with hay, no one in the central panel seems to realize that they, along with the hay wagon, are moving toward hell. In this painting, Bosch uses accessible symbols to relay his moral message, which warns people of the dangers they run. A visionary, Bosch reconciled the real and the imaginary, the marvelous and the fantastic, the comic and the tragic.

highlighted the bust and the face and left the rest of the body in the shadows to create sculpture-like volume. "To plunge things into light is to plunge them into the infinite," he once said. This painting was brought by Leonardo to France, where it was included in the collection of King Francis I in 1518. It was stolen in 1911 by an Italian painter who wanted to return it to its country of origin, and its recovery two years later made headlines around the world. The *Mona Lisa* is one of the masterpieces of the Renaissance, an era that glorified beauty and the human body.

choice of colors is not accidental: He used warm colors, reds and pinks, for the Creator, and cool colors, greens and blues, for Adam on Earth. An immense symphony of colors and forms to the glory of God, the Sistine Chapel ceiling exhibits Michelangelo's creative force, spirituality, and genius. The power emanating from the movements and monumental proportions of the figures "sculpted" in paint continues to enchant visitors today.

distorted. If you look at the painting sideways with your eye close to the page, you can see that it's a skull (5). It is there to remind us of the fleeting nature of life and that luxury, knowledge, and power are only vanities. To emphasize his message, Holbein painted another skull: It appears on the brooch on the hat of the ambassador on the left. Holbein structured his painting carefully and created flawless perspective.

When you look at this painting, your eye is first drawn to the two ambassadors, then to the table between them, filled with objects. Only after that do you notice the anamorphic image. This work, whose mystery continues to intrigue us, was one of the first life-size, full-length portraits in Western painting.

1 Everyone represented in *Night Watch* had to pay to be included; their placement depended on the amount they paid. When Rembrandt presented the finished work to the group, they were taken aback and displeased, for he had not created a traditional group portrait.

2 The captain moves forward, armed. His mouth is open, as if to give marching orders to the lieutenant in yellow, and he holds up his left hand to signal his men where to go. His right hand, gloved, rests on his major's baton.

3 The standard displays three sidelong crosses, the emblem of Amsterdam. In Rembrandt's time, Amsterdam was one of the largest and richest cities in the world.

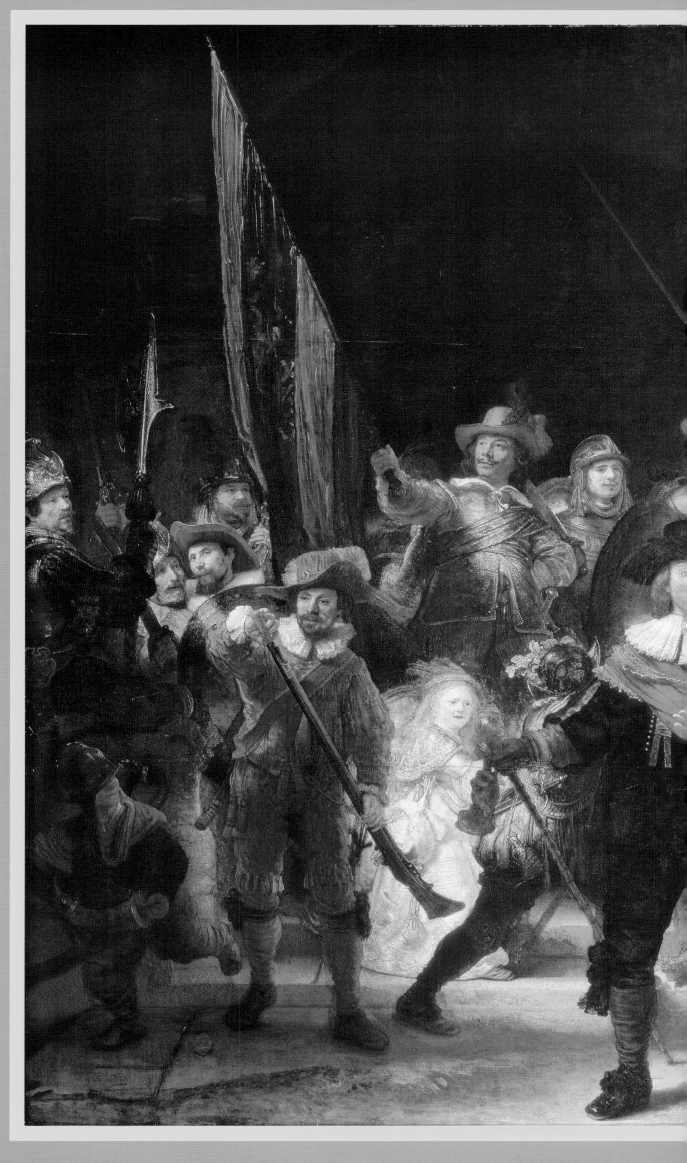

REMBRANDT van Rijn

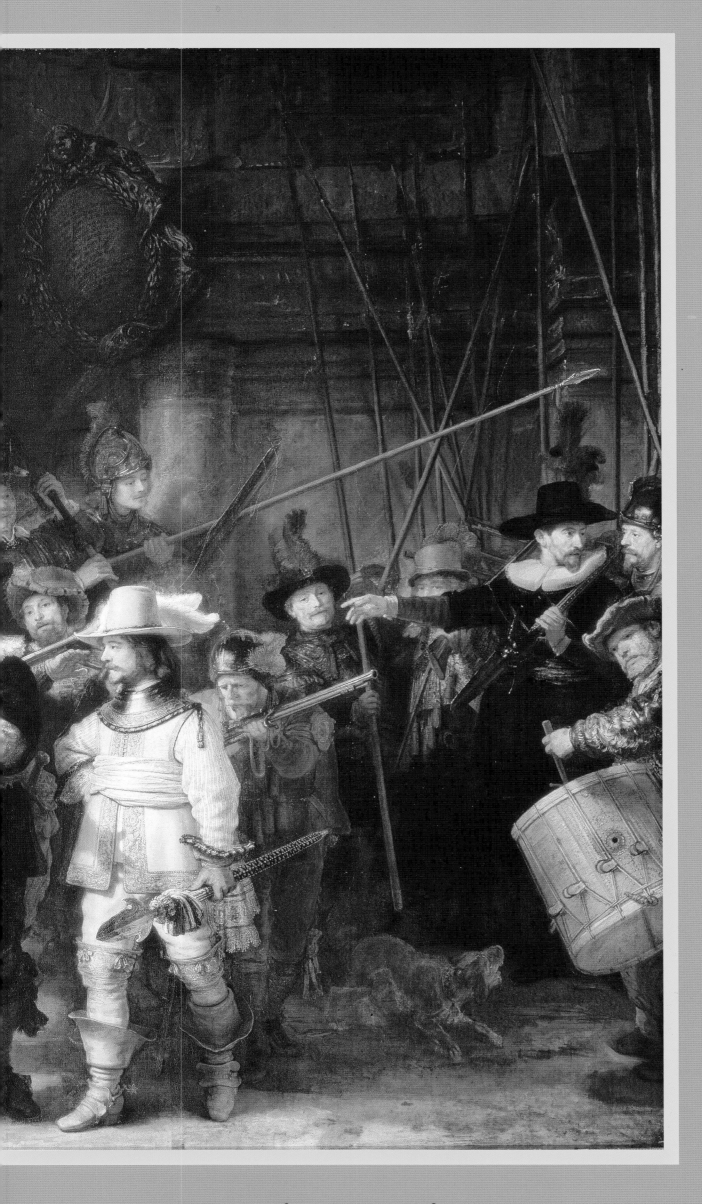

Night Watch

4

This strange young girl with a woman's face has intrigued art historians for centuries. She is probably a child Rembrandt included to animate the scene. She wears a gun in her belt and a chicken whose feet form the emblem of an archer.

5

In 1975, a museum visitor sliced the canvas with a knife. When the painting was restored, it regained its original brightness. But if this painting is so filled with light, why is it called *Night Watch*?

6

The life-size figures in this painting appear ready to step right out of the painting toward you. How was Rembrandt able to animate his painting like this?

1642

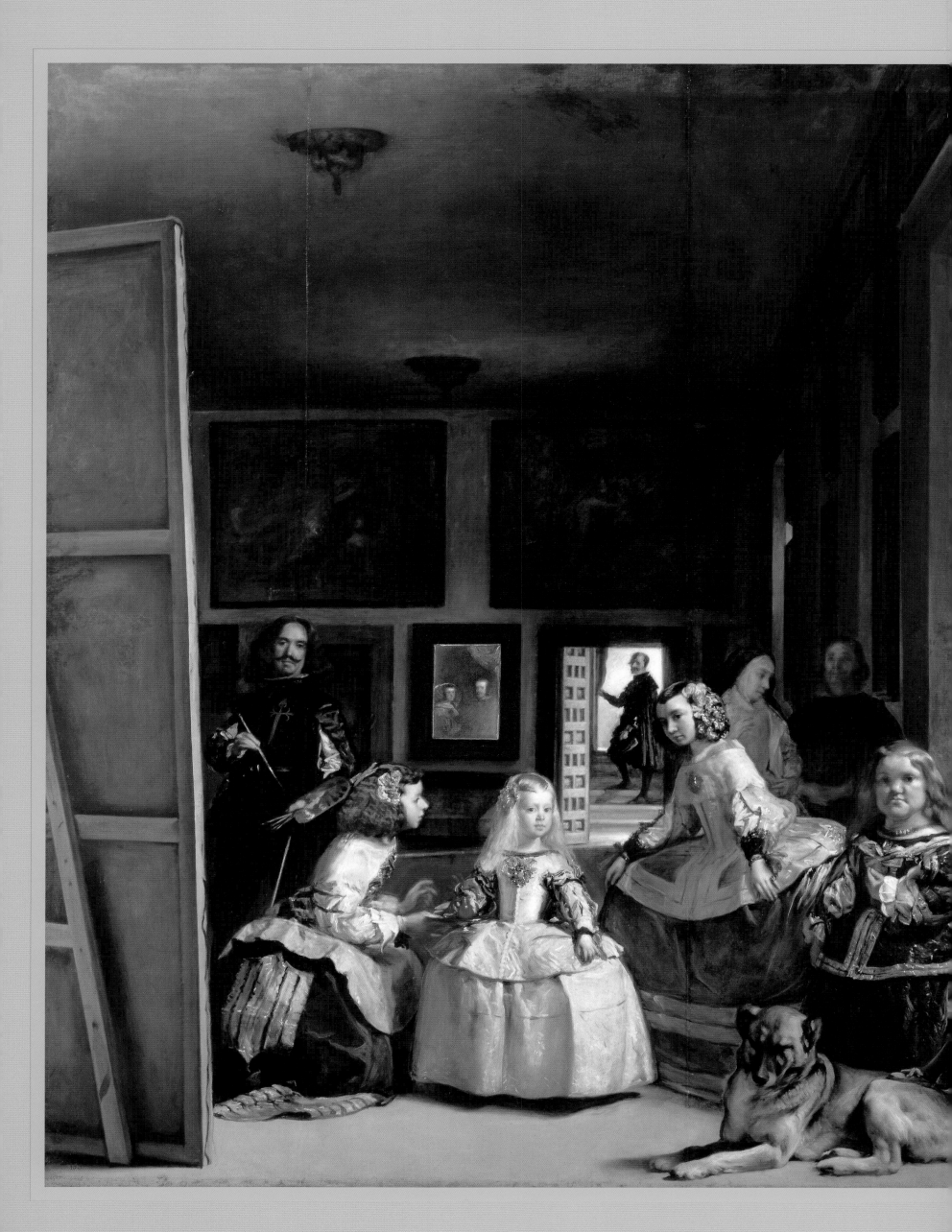

1

Only the back of this massive easel is visible. What do you think Velázquez was painting? He was probably depicting the royal couple, but we'll never know for sure, because we'll never be able to see the front of the canvas!

2

The king and queen of Spain, Philip IV and Mariana of Austria, who are believed to be the subjects of the painting whose reverse we see, are but blurry and vague reflections in the mirror. By showing the couple like this, Velázquez's painting reverses traditional portraiture!

3

Velázquez painted himself in front of his own easel, holding a long-handled brush in his right hand and his palette in the other. The only things highlighted are those related to his work: his hands and the sensitive expression on his face.

4

The five-year-old Infanta Margarita, the king and queen's only daughter, has come to visit her parents. Her youthful charm is showcased by the light that falls on her and by the contrast of the unattractive features of the dwarf on the right.

5

Menina is a Portuguese word meaning "maid of honor." Two *meninas* assist Margarita: one offers her water, and the other curtsies, respectfully awaiting orders.

6

The red cross is that of the prestigious Order of Santiago. It was added to the painting three years after *Las Meninas* was finished, when Velázquez was admitted to the Order.

7

When you look close up, the dwarf's hands, the dog, and the princess's sleeve appear blurry. Why do Velázquez's outlines often seem so fuzzy, as if he'd painted splotches?

8

The steward of the palace, who stands in the illuminated doorway, draws your eye to the mirror by appearing to gesture toward it. But where does he direct his gaze?

Diego VELÁSQUEZ
Las Meninas
1656

The young woman who sits for the painter is Clio, the muse of history. Her attributes are the trumpet, symbolic of Fame, and a laurel wreath, symbolic of Glory. Vermeer may have intended to express that painting should be guided and inspired by history, or perhaps that it is a noble art and can affect the course of history.

The painter has his back to the viewer, so he hides his face and his palette. It is probably a self-portrait of Vermeer. This picture is an allegory of painting— every element in the composition evokes the importance of the art.

Judging by its placement in the composition, the map, which introduces the external world into this intimate setting, seems to have a special importance. A map of the Netherlands, it alludes to the artist's contribution to his country's renown.

The chandelier, decorated with a two-headed eagle, the emblem of the Hapsburg rulers of Spain, reflects light from a window hidden from view by a curtain. How did Vermeer capture the sunlight that bathes the room?

The objects on the table are arranged like those in a still life. There have been many theories about their significance. For example, the plaster mask could represent sculpture or theater, and the notebook may represent drawing, or it may be a musical score.

Jan VERMEER
The Artist's Studio circa 1670

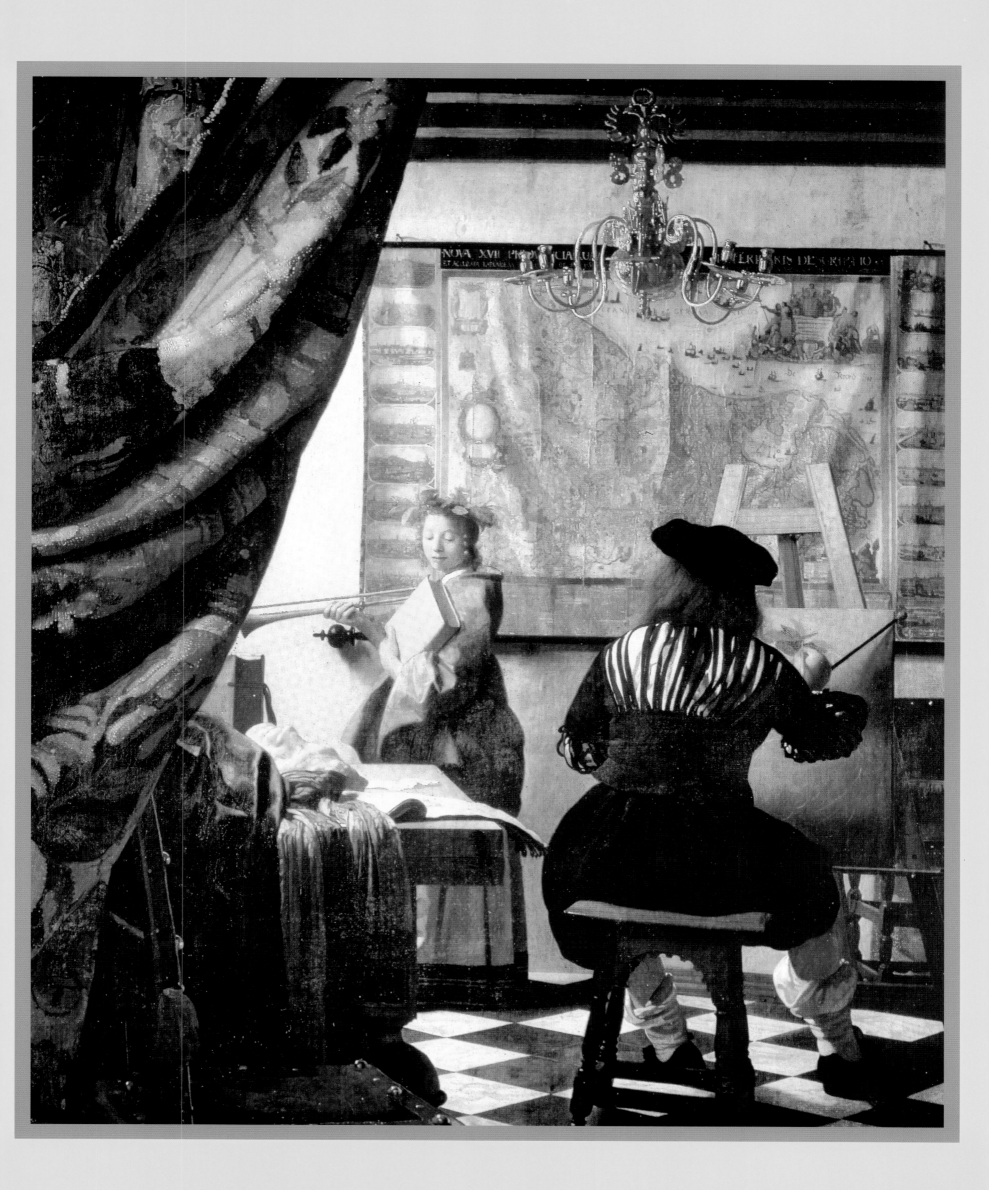

A CALL TO ARMS

The captain of a militia group orders his lieutenant to announce the company's departure. Rembrandt created a very lively composition, representing soldiers in action—a sharp contrast to the motionless group portraits of his time. His work is like a snapshot: It shows a chaotic moment in which no one stops to pose, and chaos reigns. The scene bubbles with life: The figures' legs are in position to march, their hands and weapons pointed forward, children dart in and out of the crowd, and flags flap in the wind (6). Rembrandt worked very slowly, constantly retouching his painting. As with the majority of his works, in *Night Watch* Rembrandt uses a technique known by Leonardo da Vinci called "chiaroscuro," in which he contrasts light and shade to create depth and a vibrant atmosphere. Light illuminates the diverse facial features and expressions of certain figures. As the successive coats of varnish applied to protect the painting slowly aged, the painting

A PAINTING WITHIN A PAINTING

"Where is the painting?" asked French writer Théophile Gautier when he saw *Las Meninas.* The subject of Velázquez's painting is still a mystery, for he chose not to reveal it to us. The scene takes place in the artist's studio in the royal palace in Madrid, where Velázquez was the king's official painter. The mirror

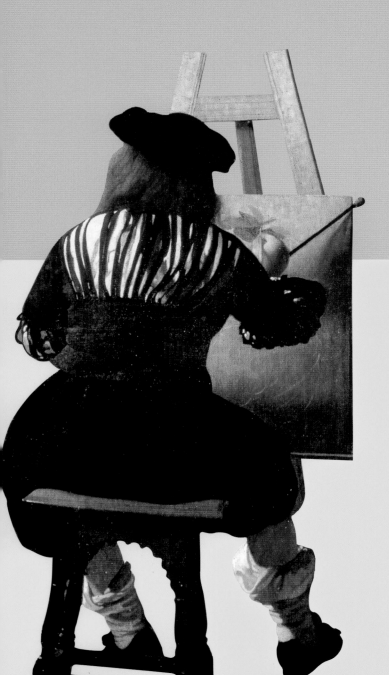

that reflects the image of the king and queen introduces a space outside the painting into it: The mirror shows the space where you are standing when you look at the painting! With this strategy, Velázquez does away with the separation between the painting and the viewer: You actually enter into the painting. The Infanta, one of her maids of honor, the dwarf, and the figure standing in the doorway all look at the viewer (originally the king and queen) (8). Velázquez is able to capture a single, fleeting

DROPS OF LIGHT

Sunlight pours in through a window hidden behind a heavy curtain. The light gives such an illusion of depth that one viewer is said to have "gone to look behind the painting to see where the marvelous sunlight through the open window came from." Light reflects on the whiteness of the wall and makes the yellow of the book vibrate. It awakens all of the different shades of blue of the young woman's dress. (Blue and yellow were Vermeer's favorite colors.) The sunlight also illuminates the objects on the table and

grew dirtier and darker, plunging the scene into obscurity, and in the nineteenth century, it was given its present title. In fact, however, the painting depicts a scene during the day: The sun casts a shadow of the captain's hand onto the lieutenant's doublet (5). One of Rembrandt's students once said on viewing this masterpiece of Dutch painting, "His work is so vivid in its conception, so clever in its composition, so full of energy, that, next to it, all other paintings look like playing cards."

moment forever, as in a photograph; it is a moment held in suspense, in which people seem to meet by chance. He paints loosely, with long, expressive strokes. His clever game of mirrors creates multiple perspectives in this closed, stage-like space, and the mystery of the painting within a painting makes this Velázquez's masterpiece, a work that would influence many painters.

bounces off the white stripes of the artist's shirt and the ripples on the surface of the map. Vermeer's poetic sensibility and his technical perfection lent his works an extraordinary impression of light and a subtle palette. Vermeer created droplets of light with dabs of white and yellow paint (4). Although he studied perspective, the artist focused above all on color. His painting is crystal clear, as if it reflects a serene reality. This painting is also called *Allegory of the Art of Painting*—though, in fact, there are many theories about the meaning of Vermeer's masterpiece.

1

A statue of Venus stands hidden in the leaves. It is draped with offerings to the goddess, such as a rose garland and three symbols of love: a bow, a quiver, and arrows. Why do you think the statue is there?

2

This couple and two others standing nearby illustrate different stages of love. In this couple, the man seduces his companion. In the middle couple, the man takes his companion by the hands for her to follow him. In the couple on the left, a man puts his arm around his companion as they walk off.

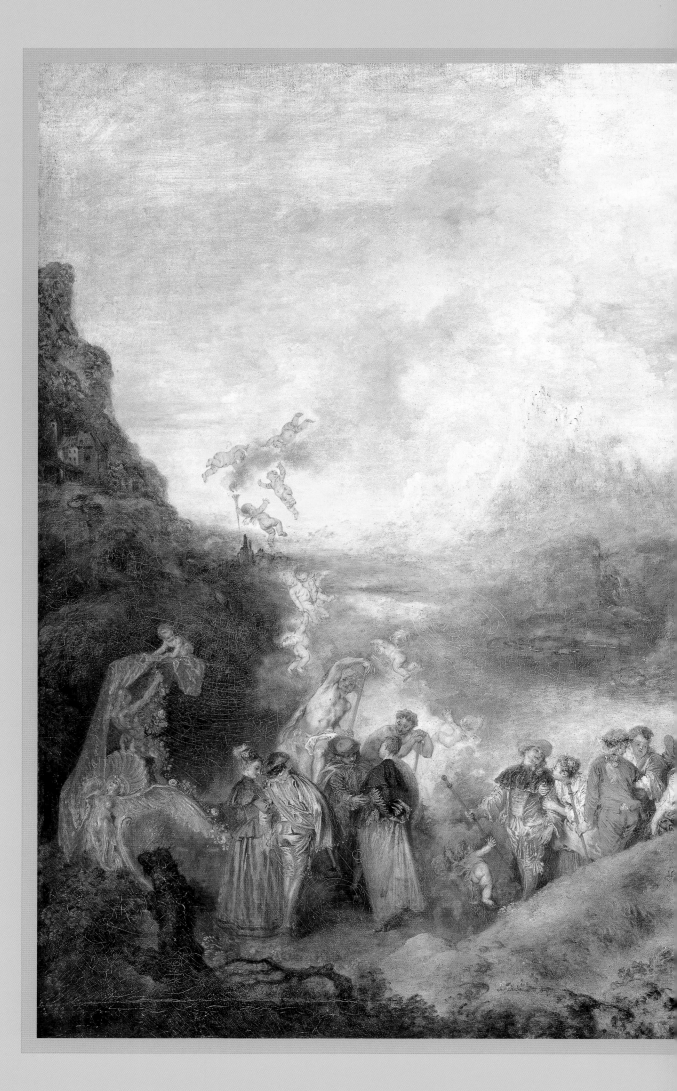

3

Strange angels flutter above the figures. They are winged cupids, from classical mythology, and they guide the lovers. At left is the golden gondola that carried the travelers across the water. It is covered with a red canopy, like a bed.

4

These couples have their backs to us and look ready to board the gondola. Do you think they are leaving the island?

5

Watteau depicts a peaceful little scene on a rocky slope, where leaves rustle in the tall trees. In the background are mountains shrouded in fog. Water and sky blend together in the light in this mysterious imaginary landscape. There are no clues to tell you whether it is spring or fall, dawn or dusk.

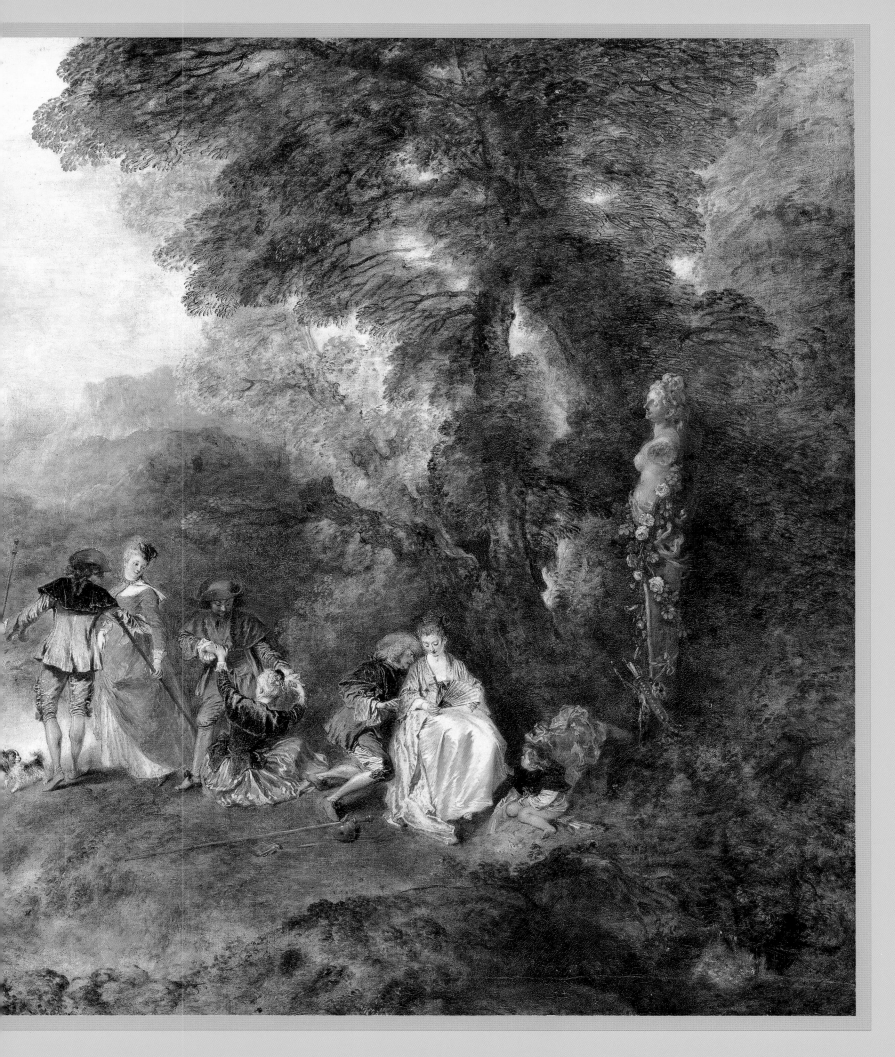

Antoine WATTEAU
Pilgrimage to Cythera

1717

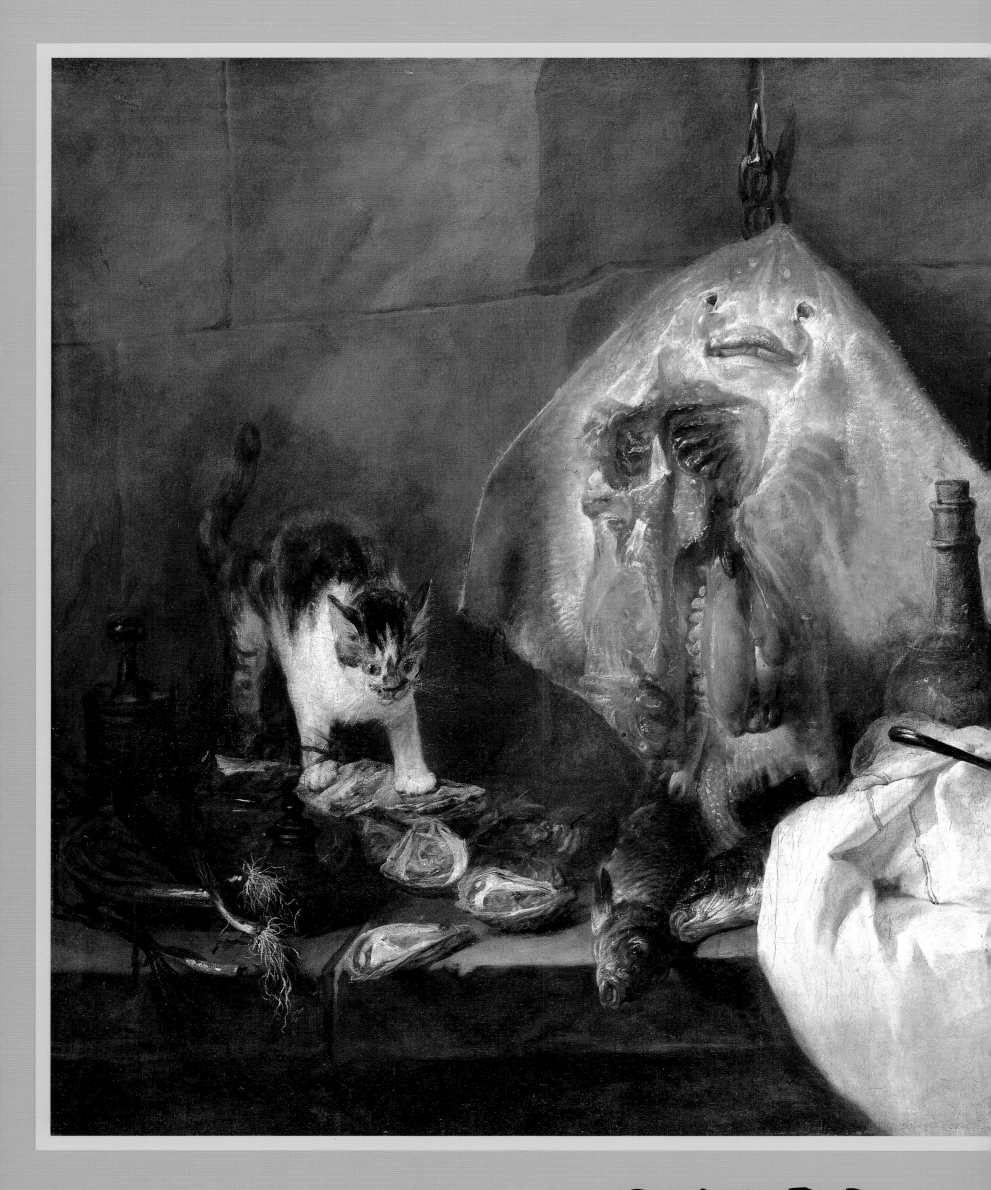

Jean-Baptiste-Siméon CHARDIN

1

There are drops of blood on the handle of the knife: It must have been used to gut the skate (the fish). The menacing blade is pointed toward the center of the table, with the tip hidden by the rumpled tablecloth.

2

"It is not white, red, or black pigment that you mix on your palette, it is the very substance of objects, it's air and light into which you dip your brush tip and apply to the canvas," French writer and philosopher Denis Diderot wrote about Chardin's painting. The subtle, pearly color of the oysters in this image proves his point.

3

The only living creature on the table is the stray cat about to pounce on the fish. Its flashing eyes contrast with the skate's glassy eyes. The pile of oysters on which the cat balances is just about to topple over; when it does, it will destroy the careful arrangement of items as a pyramid. Time is suspended.

4

Chardin must have painted this picture very quickly so that he could eat the skate the next day. Why would the artist have wanted to paint such an ugly, frightening creature?

The Skate

circa 1726

1

To end a war between Rome and Alba, the two cities agreed to a battle between the Curatius brothers (Curatii), from Alba, and the Horatius brothers (Horatii) of Rome. In this image, the Horatii swear to their father that they will fight to the death.

2

The focal point of the painting is the three swords the father of the Horatii holds in his hand. The brothers all reach for the swords at once. The oath itself does not appear in any of the ancient texts that describe the battle, so David must have imagined it.

3

Camilla is a sister of the Horatii but engaged to one of the Curatii. Here, she seems to know the outcome of the battle already: After the battle, her eldest brother will tell her of their success and she will burst into tears for having lost her beloved. Her brother, furious, will pull out his sword and kill her.

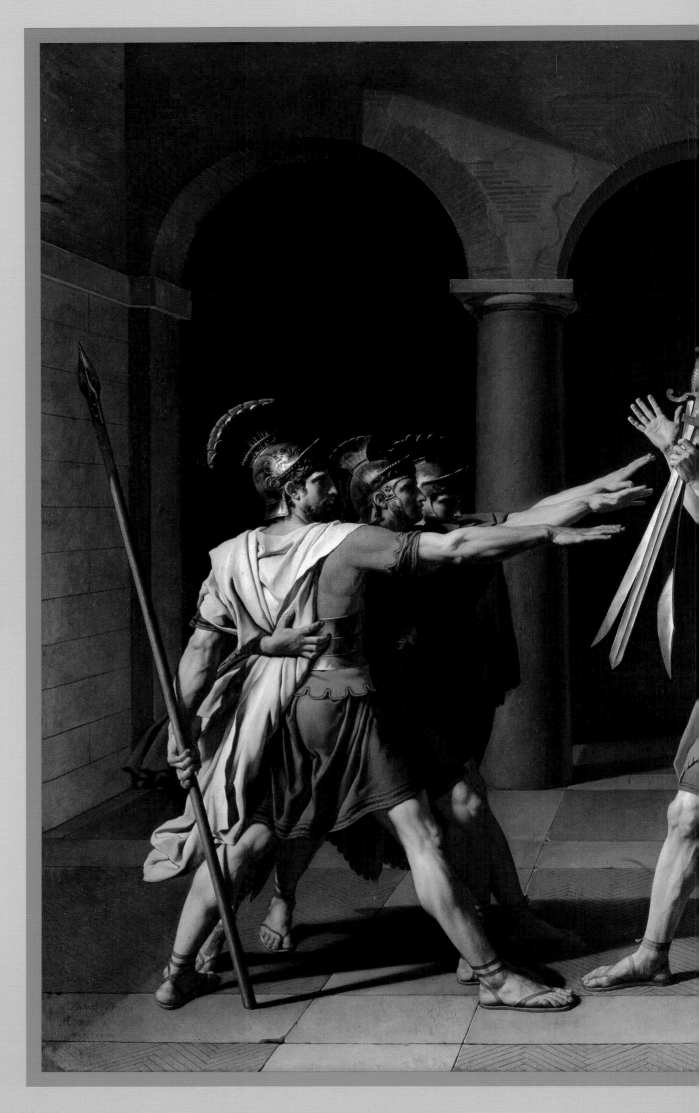

Jacques-Louis DAVID

4

The mother of the Horatii consoles her grandchildren and tries to shield them from watching. One child, however, pries her fingers apart to gaze wide eyed at the scene taking place.

5

The helmets worn by the Horatii tell us that this event is taking place in ancient Rome. David went to the city to work on this picture, hoping the location would inspire him.

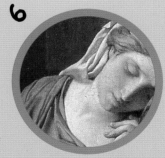

6

The woman in the blue dress and yellow mantle is Sabine, the sister of the Curatii, who is married to one of the Horatii. No matter who is victorious, both Sabine and Camilla will grieve. How are these distraught women different from the Horatii?

The Oath of the Horatii 1784

THE ISLAND OF LOVE

Where are they going, these couples mingling at the edge of the sea? Are they leaving the enchanted island of Cythera, or arriving on it? According to Greek mythology, Cythera was the home of Aphrodite, goddess of love (known to the Romans as Venus) (1). Art historians still dispute whether this painting shows an arrival or a departure; Watteau himself purposely did not give an answer. The enchanted world of this painting is like a dream: The scene is as much a departure from the island as an arrival, and the place is both specific and imaginary (4).

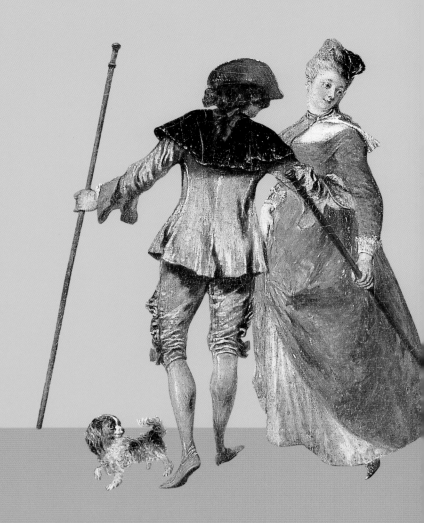

A FISH "CATHEDRAL"

Someone once gave Chardin a rabbit. Finding it beautiful, he decided to paint it, an experience that kindled his interest in still lifes. In the center of this image, an enormous gutted skate, ready to be cooked, hangs on a hook and seems to smile at us ironically—Chardin must have been fascinated by its hideous and grimacing "face" (4). "The object is disgusting, but it's the very flesh and blood of the fish!" exclaimed Denis Diderot. Later French writer Marcel Proust admired *The Skate,* calling the fish a "strange monster" and noting that "the beauty of its delicate and massive structure, tinged with red blood, blue nerves, and white muscles, [is] like the nave of a polychrome cathedral." Cooking utensils and other everyday objects (pitcher, ladle, jug, cauldron, knife) are arranged on the table at right. At left are items from the animal and vegetable kingdoms (onions, oysters, freshwater fish, and the cat). All of the elements to make a meal are present. Chardin's painting suggests that to eat, man must

ARMS AND TEARS

The central figure, the father of the Horatii, separates the men (on the left) from the women and children (on the right). This division creates tension between masculine qualities (duty, honor, and reasons of the state) and feminine ones (love and the reasons of the heart) (6). This tension is accentuated by the contrast between the strong emotions and passions that form the subject of the painting and the painting's style—its slick, icy surface, architectural symmetry, and austere décor, which set the stage for the drama of the story.

Above all, it is a subtle image of the path of love, shown by the row of couples who demonstrate love in different stages. Watteau painted with transparent tints, using short, delicate strokes to create figures inspired by life drawings in his sketchbooks. Like poetry or music, Watteau's painting is about the melancholy, nostalgia, and enchantment of love. He uses muted colors to express the quivers and imperceptible changes of love. *Pilgrimage to Cythera* gained Watteau admittance to the Royal Academy as a painter of *fêtes galantes* (elegant, refined outdoor parties fashionable at the time). This enigmatic work fascinated painters, poets, musicians, and writers alike—for example, the Goncourt brothers, a pair of French writers, called it Watteau's "marvel of marvels."

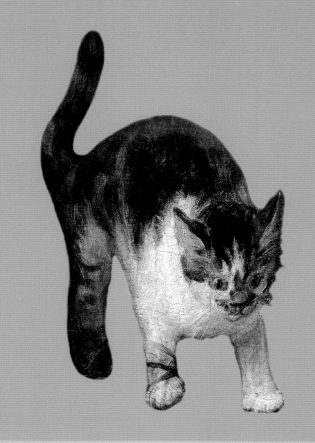

transform something repugnant, such as an animal carcass, into something delicate and edible. Chardin also intimates that humans are, like the cat, simple carnivores. This work, a technical tour de force, gained Chardin admittance to the Royal Academy as a painter of "animals and fruits." *The Skate* is vigorously and masterfully painted, and it inspired many other artists, such as Chardin's countrymen Paul Cézanne and Henri Matisse.

David, who chose a format much larger than what his royal patrons had commanded, describes the reason for this decision: "Having looked at my composition in every possible way, and seeing that it was losing its energy, I have abandoned the picture I was doing for the King and have done one for myself instead. No one will ever make me do anything detrimental to my reputation." *The Oath of the Horatii* resonated strongly: Many people came to David's studio to see it. A reaction against the frivolousness of the first half of the eighteenth century, it is a masterpiece of neoclassicism: It shows how artists turned toward morals, ideals, forms, and themes inspired by classical antiquity. This painting has been interpreted as representing praise for patriotic duty and heroism, as an assertion of classical virtues, and as political propaganda—a call to arms in the years leading up to the French Revolution. However, David's true intentions remain a mystery.

From 1808 to 1814, the Spanish fought a bloody war with Napoleon's French troops, who occupied the country. In this image, Goya depicts the horrific response to a Spanish insurrection on the night of May 2–3, 1808, in Madrid. The city skyline appears silhouetted in the background.

The man who is about to be shot next stands in a pose similar to that of Christ on the cross, as if he is offering himself as a martyr for his country. His white shirt, the color of purity, is the brightest part of the canvas. The arms of one of the corpses on the ground are spread in the same pose. What message do you think Goya was trying to get across in this painting?

The French soldiers aim at point-blank range. We view them from behind, so we can't see their faces. They appear in a line, ordered and anonymous, parts of a cold, precise war machine. Hidden behind their guns, they embody violence and blind obedience.

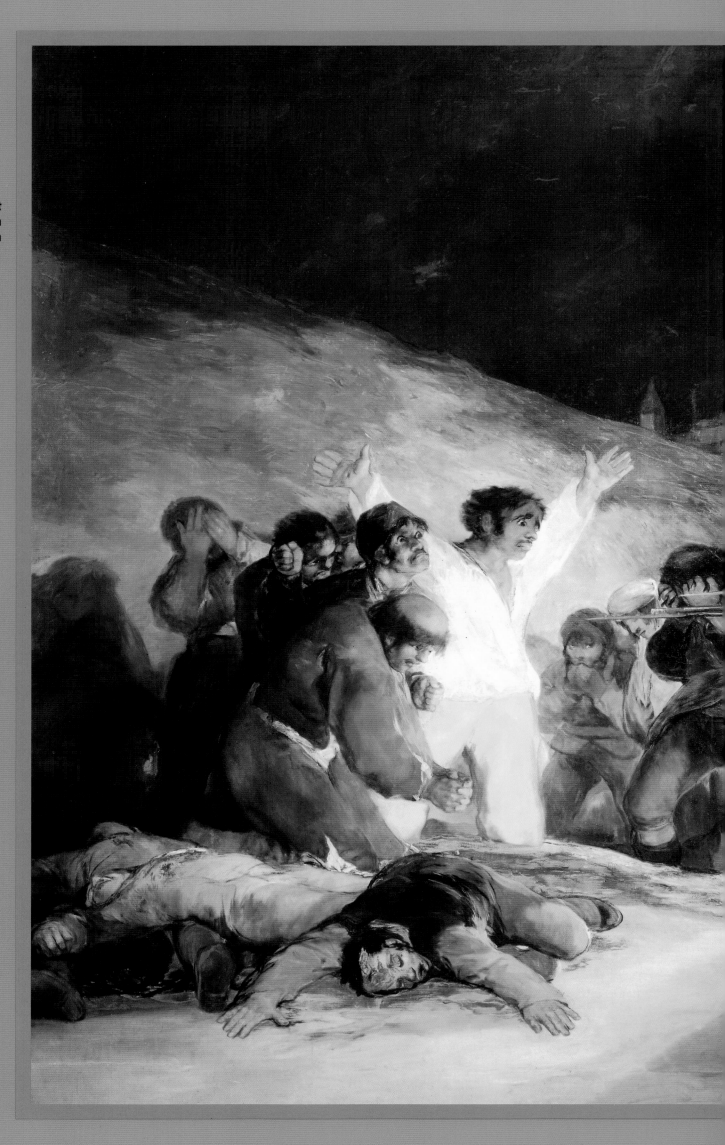

Francisco GOYA

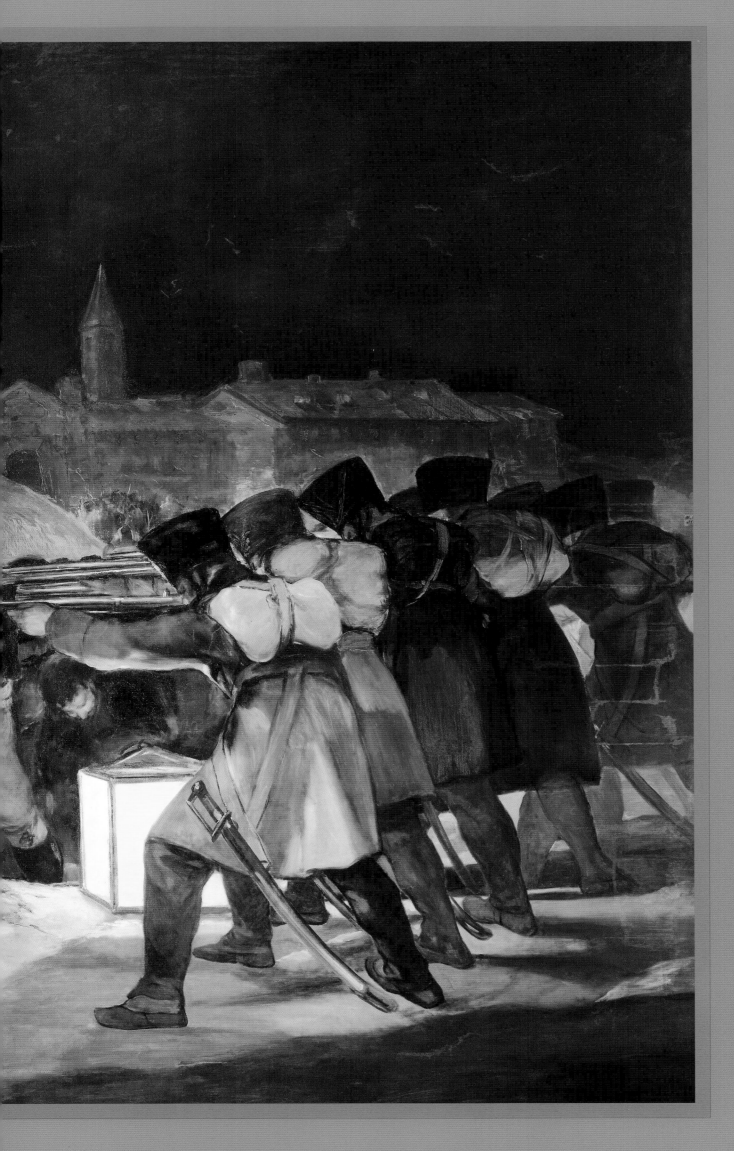

4

The only source of light is the soldiers' enormous lantern. It emphasizes the horror of the scene by harshly illuminating the victims. The shadows further create a sense of anguish.

5

This man shakes his fist threateningly, others hide their eyes, another prays: In Goya's image, hands express a variety of emotions. Though the features of the condemned are vague, their hands and eyes are accentuated to express panic, despair, hatred, and defiance.

6

A priest prays for the well-being of himself and his unfortunate companions; the Spanish church was allied with the monarchy and fought against Napoleon.

The Third of May 1808 1814

1

The black servant woman's energetic pose contrasts with those of the other women, who are calm and idle. She is the only one who is actually shown in movement: Her slipper-clad feet appear in mid-stride. The servant is undoubtedly leaving the room after having prepared the hookah (a water pipe) on the floor.

2

Afternoon sunlight fills the room. You can nearly feel the warmth that plunges these women into a sweet drowsiness. "These pale roses and embroidered cushions, this slipper, all this clarity... enters your eye like a glass of wine down the throat and you are drunk right away!" exclaimed Paul Cézanne.

3

Delacroix pushes his awareness of color and brushwork furthest in this painting. "It seems that this color . . . thinks by itself, independently from the objects it drapes," remarked French poet Charles Baudelaire, who was fascinated with Delacroix's painting.

4

The young woman kneeling at right wears a simple Oriental costume. The woman at her left, seated cross-legged, is more lavishly dressed. The bejeweled woman who reclines in the sunlight at left wears the most magnificent finery of all. Where do you think these women are lounging?

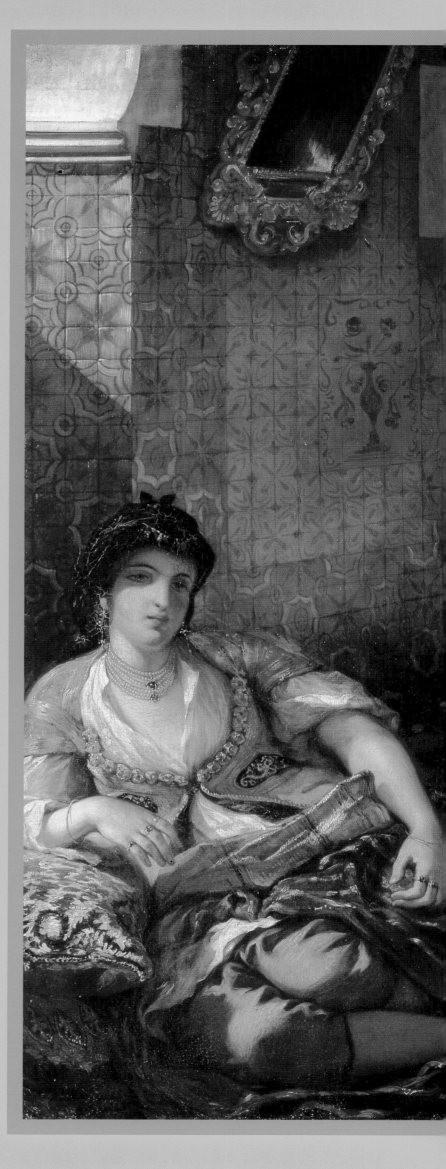

Eugène DELACROIX

The Women of Algiers 1834

1

Van Gogh pairs complementary colors: red and green, yellow and purple, blue and orange, black and white. He doesn't shy away from unusual, harsh, or unreal colors. Van Gogh once wrote to his friend, French painter Paul Gauguin: "By means of all these very diverse tones, I have wanted to express an absolute restfulness."

2

The shutters are closed, and nothing in this room gives any indication of what's outside. The order that reigns in the room is meant to inspire rest. Van Gogh painted the first version of this image in Arles, France, but he completed this picture while he was in a psychiatric hospital (where he had voluntarily committed himself because he was worried about his anxiety attacks).

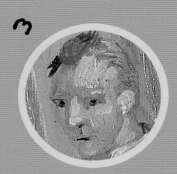

3

Van Gogh created three nearly identical versions of *The Bedroom*. Only the colors and the paintings on the wall are different. In this version, one of his self-portraits appears on the wall.

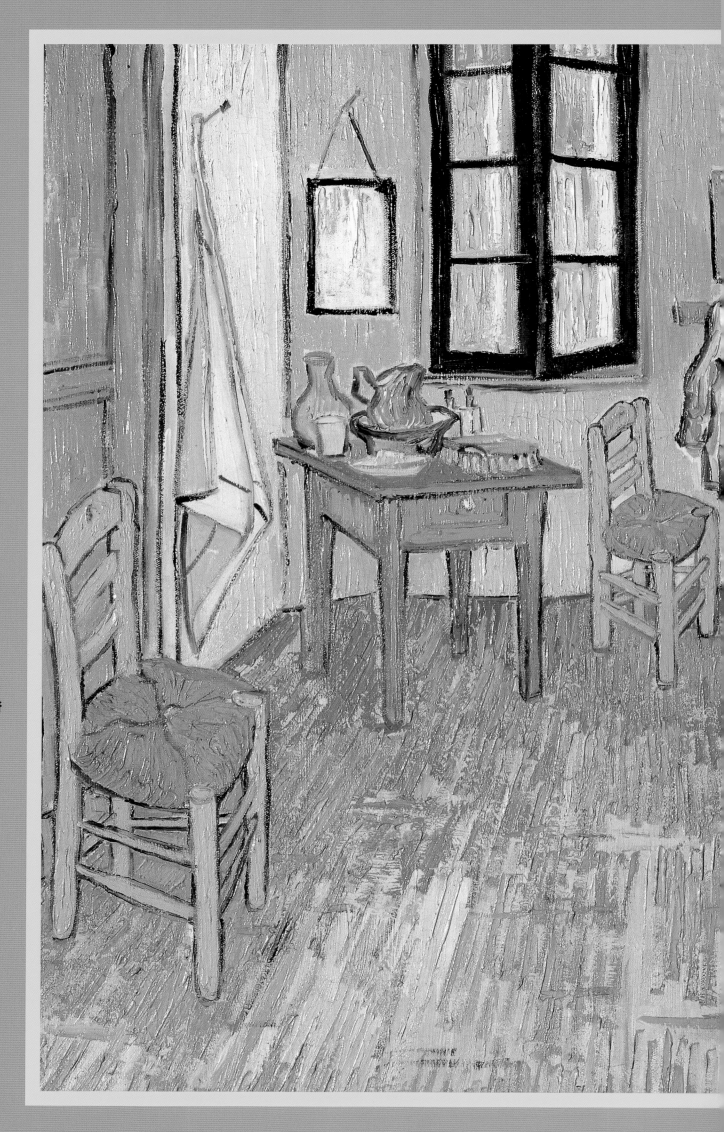

Vincent VAN GOGH

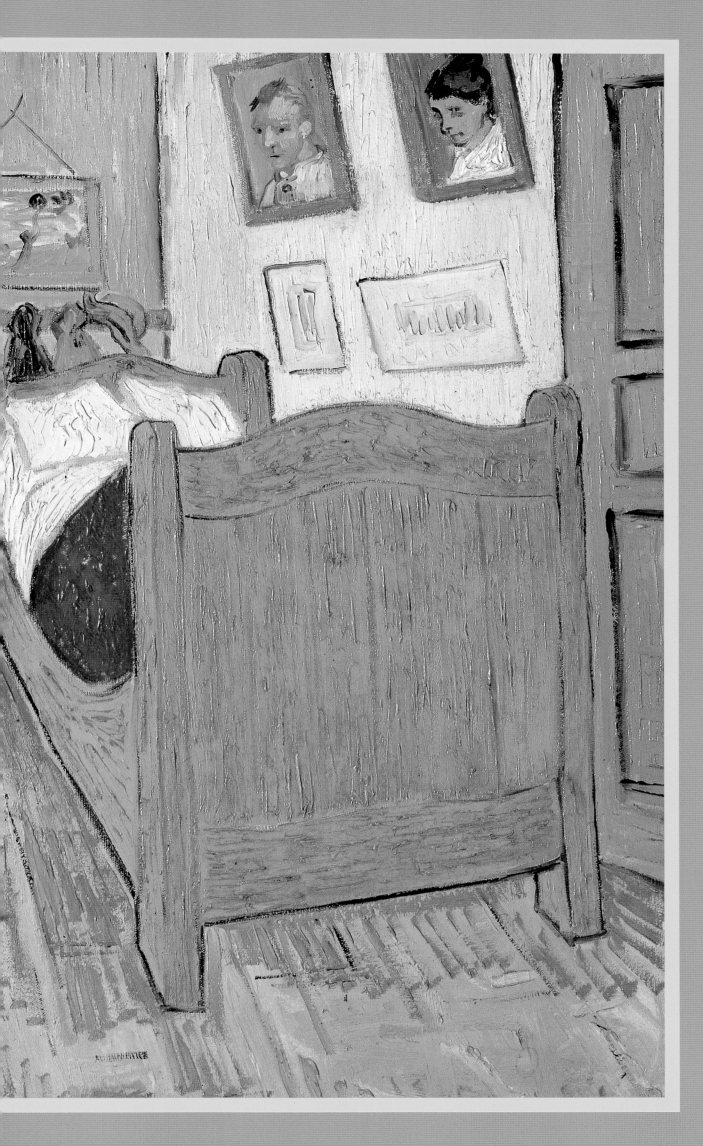

The receding lines of the floorboards seem to push the furniture to the edges of the room. The strange perspective in this painting gives you a sense of imbalance. The chairs are the only items shown in bird's-eye view, and the space seems dislocated. Do you think van Gogh discarded the laws of perspective on purpose?

5

Two Japanese woodblock prints, examples of an art form that inspired van Gogh, hang underneath the portraits. Like the prints, van Gogh's painting juxtaposes bright, flat areas of pure color outlined in black.

6

This empty chair in an empty room reinforces the sense of absence. The furniture is arranged against the walls, leaving a large unoccupied space in the middle of the room, which only heightens the feeling. Who do you think this chair is waiting for?

The Bedroom

1889

1

The water lily is a symbol of the birth of the world: It opens each morning and closes each night. It lives in the realm where water, earth, and air collide. Monet painted the lilies with short, thick strokes.

2

Monet painted these pictures aboard a boat or in a studio he built on the bank of the pond. Although his works seem almost improvised and quickly painted to capture fleeting light, in reality, he labored on them for a long time, working and reworking them in his studio. "I gave a lot of time to understanding my water lilies!" he wrote.

3

Inspired, like van Gogh, by Japanese woodblock prints, Monet built a little bridge over the pond of water lilies in his garden at Giverny, France. It is the focus of the composition; the distinct form of the rigid, stable bridge contrasts with the jumbled, shifting mass of vegetation.

4

". . . know that I am absorbed in work," wrote Monet. "These landscapes of water and reflections have become an obsession. It's beyond my old man's strength, but I still want to depict what I feel." He painted these works toward the end of his life, when he was nearly blind. In the last series of *Water Lilies,* the forms have completely dissolved.

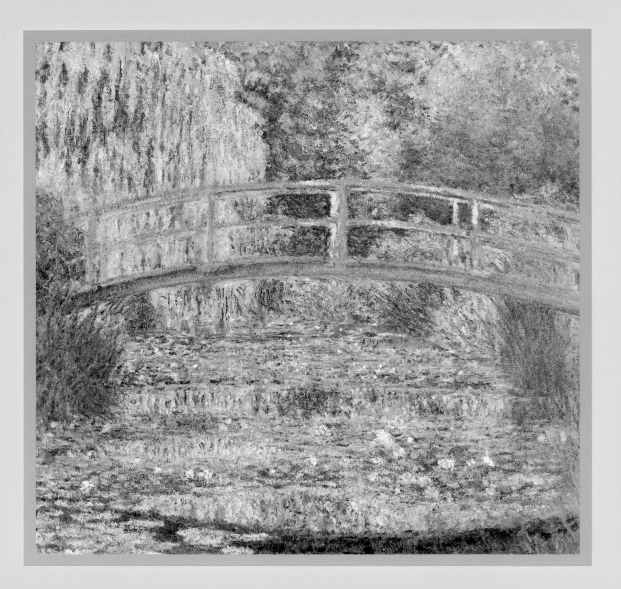

Claude MONET

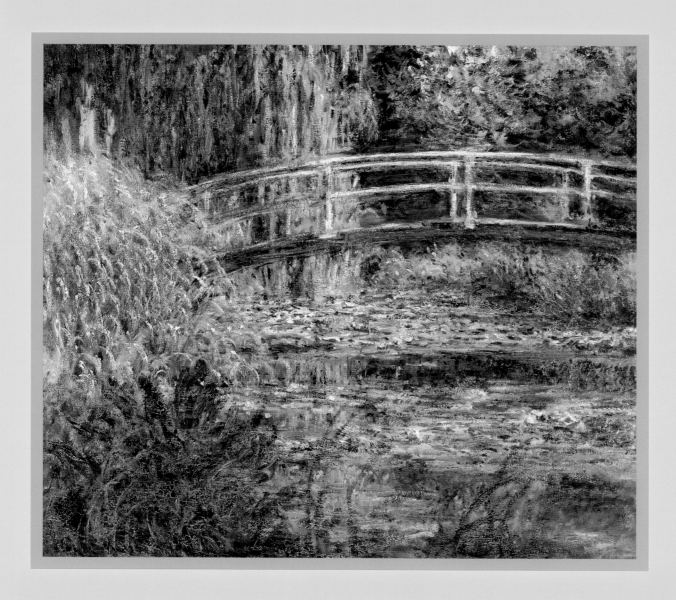

5

Willow trees and reeds create vertical lines made even longer by their reflections in the water. The water lilies create horizontal bands that grow smaller in the distance to create depth and perspective, giving the impression that the pond moves toward the viewer.

6

Every morning, a gardener prepared the surface of the pond before Monet began to paint, going out in a little boat and picking up any twigs and wilted flowers that had fallen in during the night. The gardener even washed the water-lily petals to remove any trace of dust!

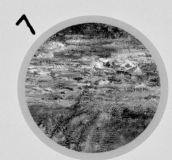

7

The most striking difference between the two paintings of the Japanese bridge is the colors Monet used. Do you think this variation reflects a change in the environment, or a change in Monet's vision of it?

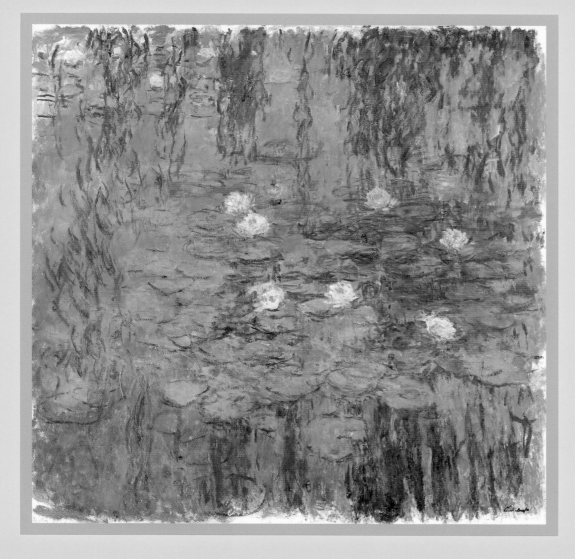

8

There is neither sky nor horizon nor perspective in this view of the water lilies. It's impossible to distinguish the flowers and leaves from their reflections. Do you think it's fair to say these paintings were the forerunners to abstract art?

Water Lilies

1899-1916

THE NIGHTMARE OF WAR

At the end of the war, Goya wrote to the Spanish government of his desire to "perpetuate, by way of his brush, the most notable and heroic actions of our glorious insurrection against Europe's tyrant." In this image, Spanish insurgents facing a firing squad appear like tragic puppets, their faces deformed by fear. Goya was one of the first artists to make "heard" the cry of humanity, a cry of despair and revolt. And, for the first time in the history of painting, anonymous figures are the heroes: artisans, peasants, and workers who gave their blood for their country and their king. Goya's painting is both a passionate tribute

SONG OF COLORS

On the way home from a trip to Morocco, Delacroix stopped to secretly visit the harem, or "apartment of women," of a Turkish corsair (pirate) in Algiers (4). Back in Paris two years later, he painted this picture. Charles Baudelaire described it as "a little poem of an interior, full of rest and silence, cluttered with rich fabrics and accessories exhaling an unidentifiable perfume." The painting gives us an intimate glimpse of beautiful, languid women lounging in the shuttered world of the harem where they

ORDER AND DISORDER

"I enormously enjoyed doing this interior of nothing at all," declared van Gogh about this painting of his bedroom in Arles, France. The clothes hanging on the wall, the ewer (a vase-shaped pitcher), the washbowl, the mirror, and the empty chairs all wait for their owner. There are two chairs: Is the second one for van Gogh's friend Paul Gauguin, who he was waiting for? Or is it for the imaginary woman van Gogh had thought about painting on his bed (6)? Though eager for affection, van Gogh lived

"MAGIC MIRRORS"

Water Lilies is a series of more than 250 paintings! Monet liked to paint the same spot at different times of day, seasons, and weather. This is how the pond of water lilies became a universe with continually changing light and color (7). Monet's friend, French politician Georges Clemenceau, described the painter's method: Monet worked on several paintings at once so that he could always be working at any given time of day. "We'd load up the wheelbarrows . . . to set up a series of plein-air (outdoor) studios, and the easels would be all lined up on the grass, ready for battle with Monet and

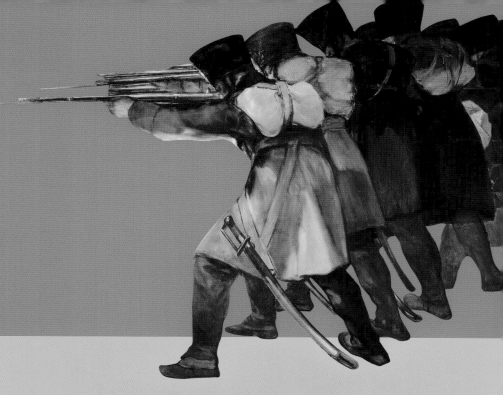

to the courage of these people and an accusation against the cruelty and absurdity of war (2). He expresses himself in thick strokes of dark colors illuminated with yellow, white, and red. *The Third of May* portrays an unbearable feeling of barbarism and despair.

live. Delacroix made an important discovery in Morocco: Light is what makes color "sing." Seized by the magic of the Orient, he wrote to a friend, "It's a place for painters. . .beauty is everywhere. . . .come to Barbary, you'll see the natural qualities always disguised in our land, you'll feel the precious and rare influence of the sun that penetrates everything with life." To paint *The Women of Algiers,* Delacroix combined several quick sketches from his travels into a detailed composition. The subject of this painting inspired many artists, such as Pablo Picasso, and Delacroix's skillful use of colors fascinated the Impressionists: "There is no painting in the world more beautiful," said French painter Pierre-Auguste Renoir.

alone; this little room has a poignant sense of solitude. Two pillows, two chairs, two drawings, two portraits: Everything is paired. Even the pieces of furniture, the "actors" in this scene, seem to converse among themselves. Van Gogh gives them a basic, solid structure to express his desire for simplicity and familial security, noting, "The broad lines of the furniture must again express inviolable rest." However, the subtle imbalance in the perspective suggests that this tranquillity is only on the surface: Behind it lies the solitude of confinement, waiting, and anxiety (4).

the sun." Monet accomplished the remarkable feat of immobilizing an instant, of representing the fluid and intangible—reflections on the water, rustling leaves, light dissolving things into a million shades and strokes. In this work, shapes disintegrate until they become abstractions. Monet's *Water Lilies* are immense symphonies in which water, air, and vegetation meet and blend together in the light. They herald abstract painting of the second half of the twentieth century (8).

1

These young women (*les demoiselles,* in French) stare at us immodestly. Many of Picasso's contemporaries found this painting ugly and shocking, an accusation to which the painter retorted, "Every masterpiece has come into the world with a measure of ugliness in it. That ugliness is the sign of the creator's struggle to say a new thing in a new way."

2

Although the women's faces are shown from the front, their noses appear in profile to the left. Picasso noted, "The nose from the side: I painted it that way on purpose. I did it in such a way that people were obliged to see a nose. Later on, they'll have seen, or will see, that the nose was not askew."

3

This round face with simplified features was inspired by primitive Spanish sculpture, which Picasso admired. He painted the figures in warm colors, pale pink and red ochre, that contrast harshly with the cold whites and blues of the drapery.

4

In the figures at right, Picasso replaced the shadows with parallel lines that suggest a shadow cast by the nose as well as the lines of African masks. Picasso, who had just discovered African art, was fascinated by it.

5

This hand looks as if it were carved by an ax. These angular women are dense and solid, like statues constructed with blocks. They stand in a curtained space—the folds of the curtain are also shown as overlapping flat planes. There is no perspective in this painting, and the subjects have been reduced to their basic volumes.

6

This crouching woman seems deformed: We see her from the back, but her face is turned toward us. This is Picasso's first attempt at showing different angles of observation. The figures become more and more stylized from left to right. What artistic movement did this painting mark the start of?

Pablo PICASSO

Les

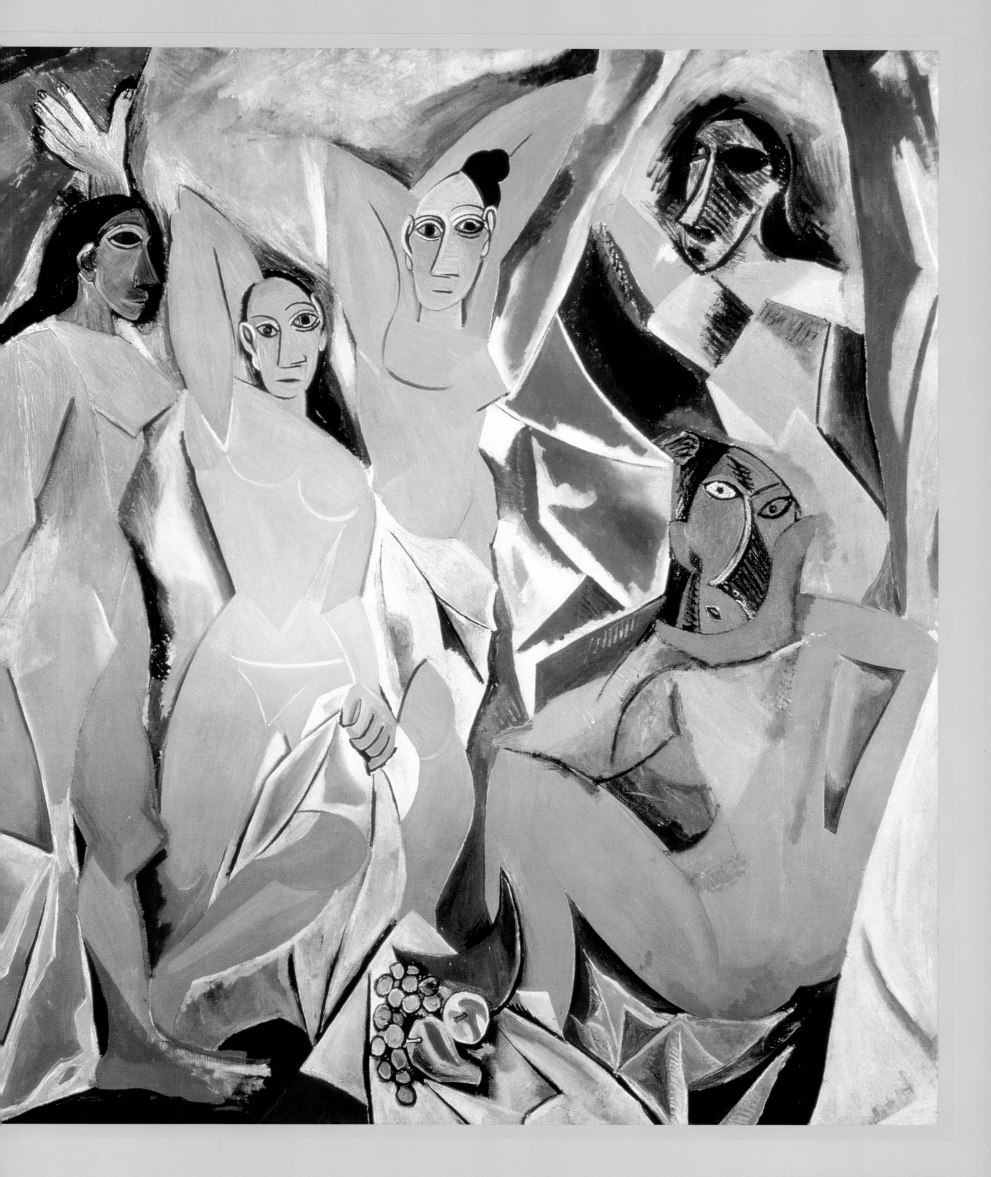

Demoiselles d'Avignon 1907

1 "From the beginning, the word 'composition' resonated in me like a prayer." This boat with its black oars might remind you of Noah's Ark. It is a religious motif that appeared in other examples of Kandinsky's works. Why do you think Kandinsky painted figurative forms in this almost abstract painting?

2 The composition gravitates toward this oval shape, outlined in black. It forms the central core of the painting, like the eye of a tornado. Shapes and colors seem to move toward the upper right corner, creating a diagonal that divides the painting in half. The top half is tumultuous, and the bottom half is more calm.

3 "Color is a way to exert a direct influence on the soul," Kandinsky wrote. "Color is the key, the eye is the hammer that strikes it, and the soul is the instrument of a thousand strings. The artist is the hand that plays one key or another to trigger the vibrations of the soul." Colors, like shapes, had a meaning for the artist.

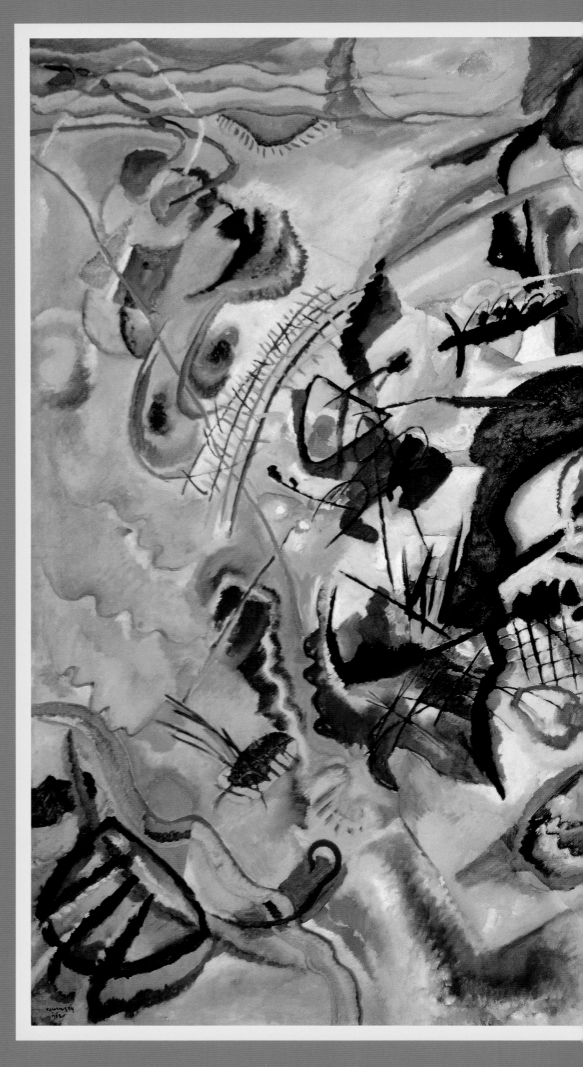

4 This shape, like many others, appears in many of Kandinsky's preparatory sketches. Kandinsky, who completed more than thirty drawings and watercolors before making *Composition VII*, called his *Compositions* his most carefully developed paintings. They were, he wrote, "the expression of an interior feeling, slowly formed."

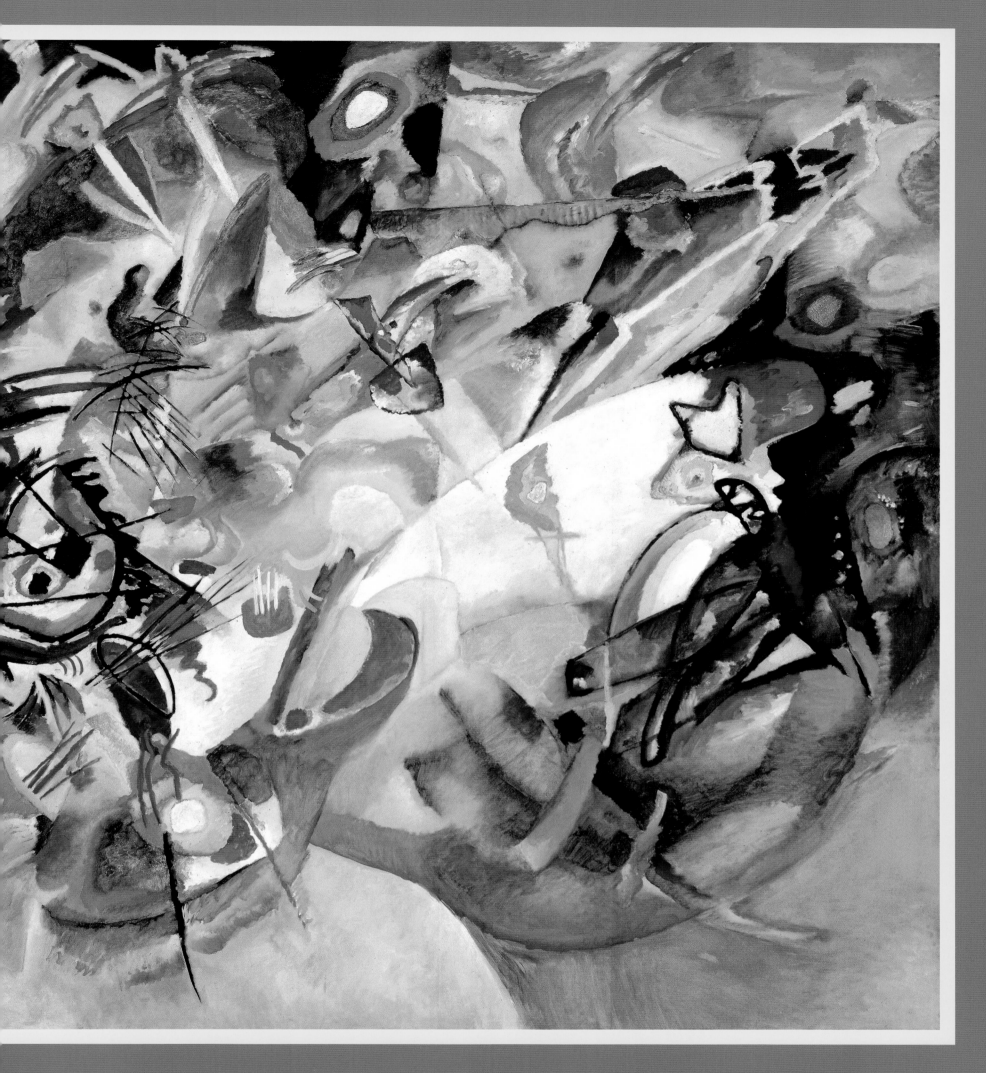

Wassily KANDINSKY

Composition VII

1913

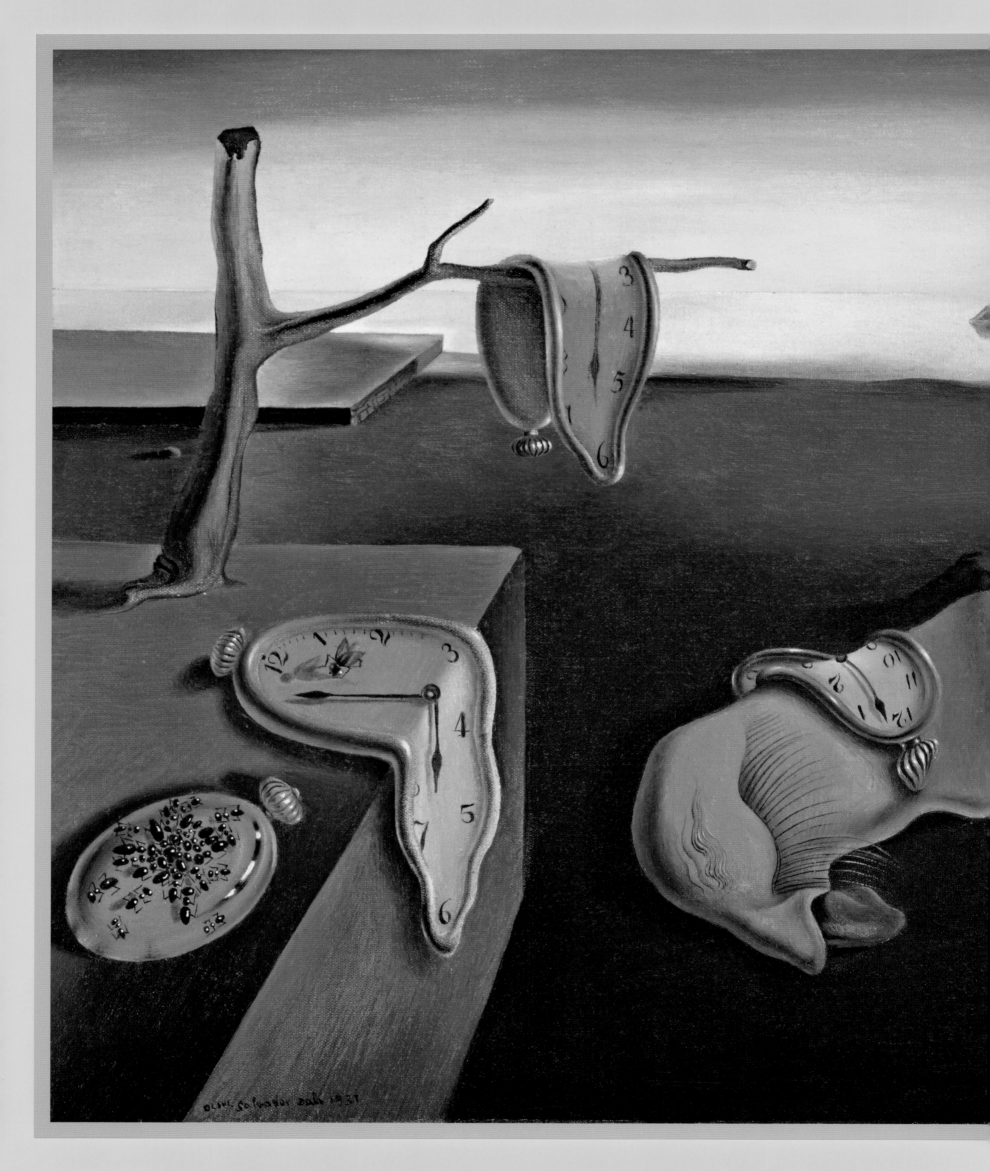

1931 Salvador DALÍ

1

"Everyone always asks me why they are soft, and I always reply, 'Hard or soft, it doesn't matter, as long as they tell the right time.'" Dalí's sense of humor is legendary. But what did this painting of three melting watches, each showing a different time, really mean?

2

These eyelashes belong to a strange face without a mouth. The features appear to be Dalí's own. This self-portrait with closed eyes evokes Dalí's dream-inspired visions.

3

Like other Surrealist artists, Dalí was fascinated by the mystery of the unconscious, and by opposites such as soft and hard, solid and liquid. The soft objects symbolize decomposition, time, and death, while the hard objects, such as rocks, evoke stability and refuge.

4

Even when he was young, Dalí was fascinated and disturbed by the way ants eat animal carcasses. In his art, ants become symbols of decomposition and anxiety. Here, they swarm on a watch like maggots on meat.

The Persistence of Memory

1

On August 5, 1962, actress Marilyn Monroe committed suicide, and a media frenzy followed. Andy Warhol was fascinated by Monroe's notoriety and how much the American public loved her.

2

These multiple images in rows are like funeral effigies. They evoke the omnipresence of Monroe in the media and the immense power of images.

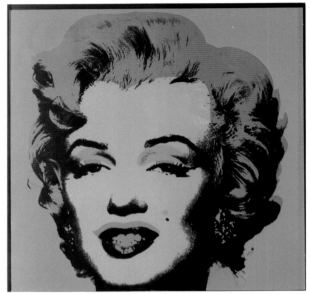
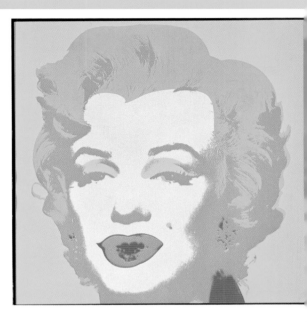
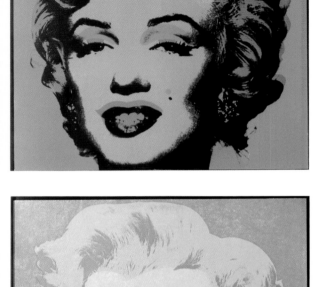
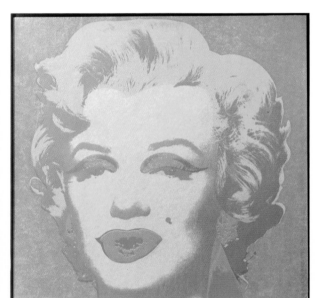
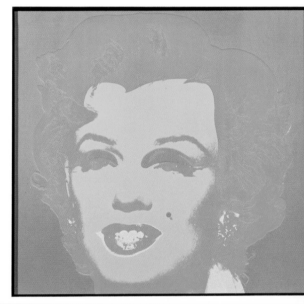

3

The photograph used to create this work shows through the color. It was a publicity shot for the movie that had made Monroe so famous. These portraits of her would, in turn, make Warhol famous all over the world.

4

Acrylic paints allowed Warhol to achieve vivid and artificial colors that resemble the colors of advertisements. Such garish colors "made up" this face into a consumer product.

5

To create multiple images, Warhol used a technique called "serigraphy," or silk screen. In this technique, based on stenciling, ink is brushed through a silk screen to imprint an image onto paper.

Andy WARHOL

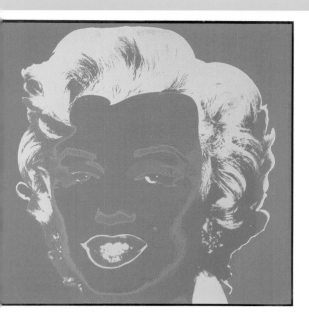
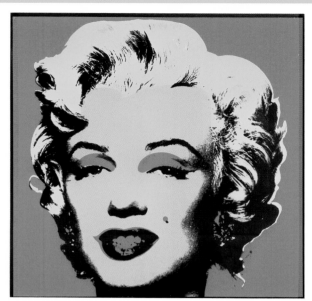
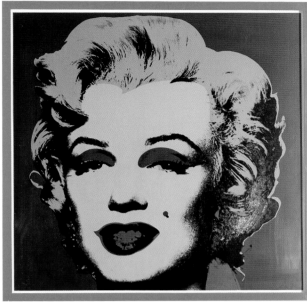
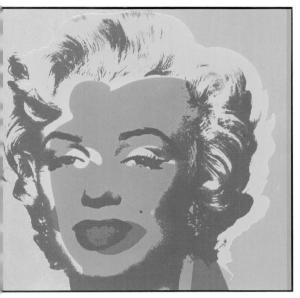
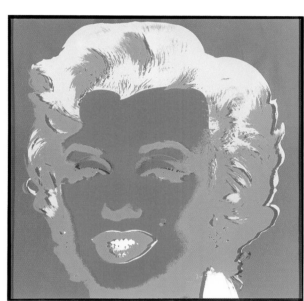
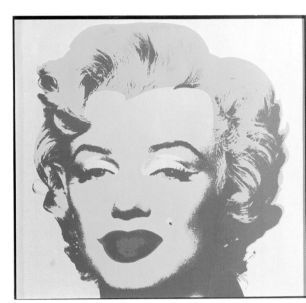

6

The silk screen allows a portrait to be printed hundreds of times. The process of reproduction reduces the image to a kind of motif or logo.

7

Monroe's face looks like a poorly printed document—her lipstick is bleeding and the yellow of her hair runs onto her face. When criticized about this effect, Warhol responded, "I like it that way." The artist enjoyed playing with technique and creating images that had the impression of being printed documents.

8

"If you want to know all about Andy Warhol, just look at the surface of my paintings and films and me, and there I am," Warhol declared. "There's nothing behind it." Do you think Warhol's artworks are just witty jokes containing no message?

Marilyn 1964

DEMOISELLES IN PIECES

"Your painting looks as if you wanted us to eat tow (fibers) or drink gasoline," exclaimed French painter Georges Braque. When Picasso's friends saw *Les Demoiselles d'Avignon*, they were dumbfounded and dismayed. Picasso had made hundreds of sketches and studies for this image, working for more than nine months in secrecy on this huge painting, which measures more than eight feet (two and a half meters) square. The fragmented forms and volumes show different aspects of

VERTIGO IN COLOR

When Kandinsky entered his studio one day, he saw "a painting of indescribable beauty, saturated with an interior blaze." It was actually one of his paintings standing upside down! This experience convinced the artist that it was useless to represent reality in his painting. *Composition VII* is a dizzying whirlpool that seems to express anxiety and gives the impression of a dramatic event—it was in fact painted on the eve of World War I. Biblical images evoking the Apocalypse, the Flood, and the Last Judgment are hidden or disguised in colored shapes that bubble in space. Such themes return frequently in the artist's prewar paintings. Kandinsky let his viewers figure out his images, allowing them

WATCHES SOFT AS RIPENED CHEESE

"We had finished dinner with an excellent camembert, and, when I was alone, I stayed for a minute sitting at the table, reflecting on the problems posed by the 'super softness' of this runny cheese. . . .The painting that I'm in the middle of working on depicts a landscape. . . .This landscape should be a foundation for an idea, but what? . . .I am about to turn off the light and leave, when I 'see' the solution literally: two soft watches that hang pathetically on the branch of an olive tree." In *The Persistence of Memory*, Dalí evokes both the anxiety of time marching unstoppably toward death and the immobility of time in the realm of the unconscious and dreams: This is why the watches are stopped and

A STAR SERIES

This image was created during a period of immense American consumerism after World War II. Using silk screening, Warhol was able to personalize objects and depersonalize people. Monroe is no longer an individual here; she is a consumer product like Coca Cola or Campbell's soup, both of which Warhol also used as subjects in a series of prints, as if the items

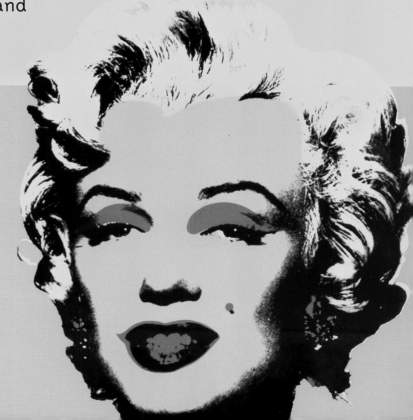